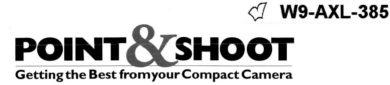

POINT & SHOOT
Getting the Best from your Compact Camera

PHOTOGRAPHING CHILDREN

LIZ WALKER

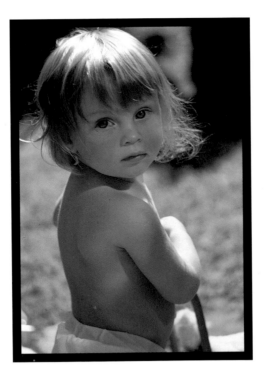

Amphoto Books, an imprint of Watson-Guptill Publications/New York

Contents

First published in the United States
and Canada in 1995 by Amphoto
Books, an imprint of Watson-Guptill
Publications, Inc., 1515 Broadway,
New York, NY 10036.

Edited and designed by Hamlyn,
an imprint of Reed Consumer
Books Limited, Michelin House
81 Fulham Road, London SW3 6RB
Executive Editor Sarah Polden
Art Editor John Grain
Executive Art Editor Vivienne Brar
Art Director Jacqui Small
Picture Researcher Wendy Gay
Production Juliette Butler

Library of Congress Cataloguing-in-
Publication Data
Walker, Liz. 1966 –
Photographing Children / Liz
Walker. p. cm.–
(Point & Shoot)
Includes index.
ISBN 0-8174-5486-1
1. Photography of
children – Amateurs'
manuals.
2. Electric eye cameras –
Amateurs' manuals.
1. Title. II. Series.
TR681.C5W34 1995
 95-1418
 CIP
Printed in Hong Kong
Produced By Mandarin Offset

Introduction

Nothing is as precious as a child, and few things are as photogenic. Youth slips by so quickly that every opportunity to catch a child's energy and laughter on film must be taken. In this way you can create a permanent record of your children's progress and share all those happy moments with friends and distant relatives who will treasure photographs from home.

What is more, expensive, elaborate cameras are not essential to take extra special pictures. Easy and quick to use, compact cameras take all the effort out of photography, helping you to concentrate on the three most important elements behind child portraiture: composition, rapport and timing.

This book gives you the practical expertise to guide your child photography towards more creative and rewarding results. Including a host of simple technique tips and ideas for using accessories, every aspect of your child's life is covered, from parties and play to schools, holidays and hobbies. With this book in hand, you will soon boost the visual impact of every picture you take. Experimentation and imagination will lead the way towards pictures you are so delighted with you will want to frame them all!

A soft quilt or blanket provides an excellent backdrop for a delightful portrait of a new baby.

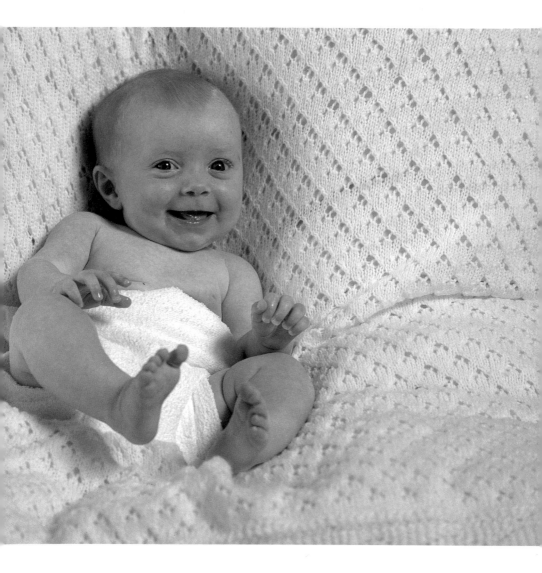

Babies

From the moment they are born, our children are the most photogenic of all human subjects. Precious and vulnerable, babies are naturally the pride and joy of their parents, but they grow up fast, which means your pictures of them are all the more important, as souvenirs of their earliest youth. What photo diary would be complete without the first three years of a person's life?

BELOW *Try to avoid using flash when photographing newborn babies. Load up with fast film instead.*

Newborn babes That joyous telephone call announcing the birth of a healthy new grandchild, niece or nephew is an exciting moment to be savored. It is also the signal to pack up your camera and head off for the first meeting.

In all the excitement it is easy to forget how overwhelmed the baby must feel, surrounded by blurred

shapes, odd smells and noises. Try to avoid startling newborn babies with flash from close range.

To get round the problem of dull conditions in a hospital ward (where most automatic built-in flash will fire whether you want it to or not), load up the camera with a fast ISO 400 black and white film. Black and white print films will not record the ghastly green fluorescent color of the hospital lighting, and the fast ISO rating (see Jargonbuster) of the film means it is

Do's and Don'ts

■ BELOW Don't forget to have a picture taken of the pregnant mother.

■ LEFT The baby bouncer is a real ally when it comes to animated portraits of your child. Do kneel or crouch down, bringing the camera to the baby's eye level to avoid dwarfing him.

■ Don't prolong a session if the baby is overly tired or bored.

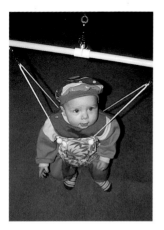

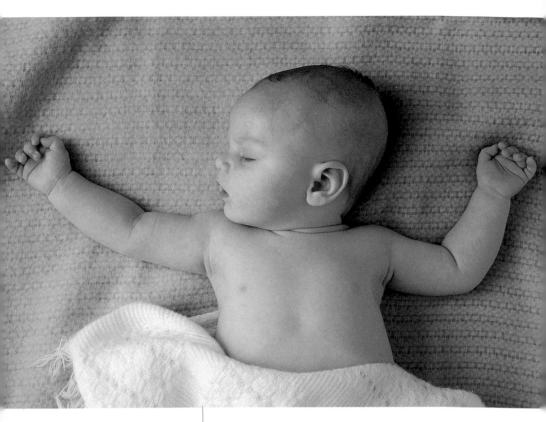

ABOVE *For interior scenes load up the camera with a faster ISO rating than usual (instead of ISO 100, use ISO 200 or 400).*

ABOVE RIGHT *Use available sunlight wherever possible to avoid creating harsh flash shadows.*

more sensitive to the available light from windows and from fluorescent or tungsten light tubes overhead.

If you want color results, use a fast ISO 400 color print film and ask the processing lab to hand print the best results, filtering out any unwanted color casts.

Carriages and cribs With the baby safely installed at home, you will doubtless want to send portraits to friends and relatives. As newborn babies cannot sit up on their own, you will have to take your pictures from above, or use some form of support to prop the baby into a sitting position.

Pictures in the carriage or crib require adopting an aerial perspective, angling the camera down from

Camera Skills

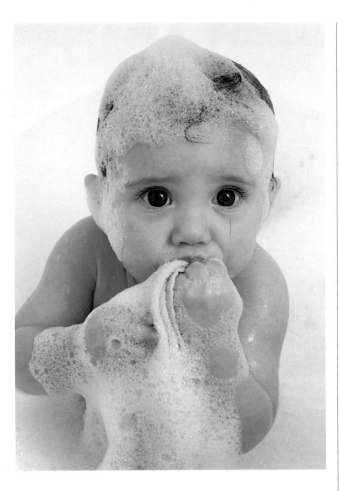

■ As babies are so small, you may find that you have to get very close to them in order to fill the viewfinder area. Check the minimum focusing distance for your camera (usually around 20 inches) and make sure that the baby is at least this distance away from the camera lens, otherwise he will not be sharply focused.

■ One alternative to taking a close-up shot and risking a blurred image is to have your prints selectively enlarged. Take the negative back to the processing shop along with the original print and show them how you want the image to be cropped.

above and filling the viewfinder with the baby. Avoid wasting too much of the picture area – you do not want to show off the room, blankets or crib bars – so come in close to make the baby appear large in frame.

Bath time You will need an assistant for this one as it is practically impossible to take pictures of the baby in the bath and bathe him at the same time! You could try with the camera on self-time, but you will need to put the camera on a tripod and be very adept at juggling!

Picture Pointers

■ RIGHT Concentrate on what you can see in the viewfinder – extra clutter will spoil the shot.

■ BELOW Watch you do not accidentally crop your baby's head off in frame! This happens when you get so close to the subject that what you see in the viewfinder is not exactly what you get in the camera's taking lens, a mistake known as parallax error.

If you are in a small bathroom, take care that the flash does not cast stark shadows on the wall behind. If your camera allows it, set the flash to 'fill in' mode which will balance the available window light.

It is a good idea to avoid blatantly showing off the baby's private parts – no one really wants to see them in a picture! For a more discreet composition, use bath toys floating in strategic positions or add a small amount of mild baby bubble bath to the tub, allowing the foam to spread over the surface of the water.

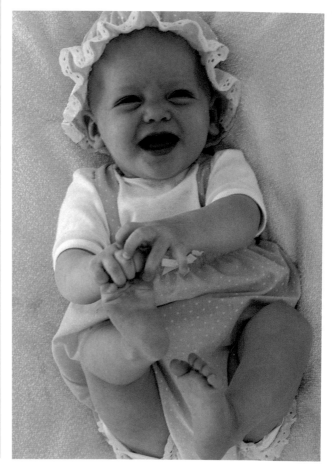

Part of the family For attractive formal baby portraits it is worth considering three main things: the baby's clothing, the choice of setting and how to hold him up for the camera.

As far as clothing goes, avoid the temptation to dress your baby in the most colorful and brightly patterned items available as this will distract attention from his face and eyes, which should be the main focus of your composition. Instead, choose plain clothes in a neutral shade (a white or blue babygrow would be ideal for the occasion). A dribbly, messy bib should be removed just before the picture is taken.

The choice of setting for the photograph is up to you, but remember it is easier to take an attractive baby portrait using natural light, perhaps in the park or garden. Check all four corners of the viewfinder to spot any unwanted rubbish and colorful toys sneaking into the picture.

Get various members of your family (or friends) to hold the baby and show him to the camera. Interesting pose variations might be to have the baby looking into the camera from over his grandmother's shoulder; to sit the baby on a rug, leaning back against his father's arm; to show the baby in profile, looking directly into his mother's eyes; to support the baby in a seated position in his pushchair or highchair.

ABOVE *Get your child to smile by attaching a happy cut-out face to the front of the camera. A natural smile can make a photograph.*

Trouble Shooter

Q How can I get my baby to smile at the camera?

1 Click your fingers and call the baby's name, holding the camera steady in your other hand.

2 Attach a smiling paper face to your camera, cutting holes in the face for the lens, viewfinder and flash to poke through.

3 Play a game of peek-a-boo from behind the camera, using a tripod to hold it steady and aligned with the baby's face.

Toddlers

BELOW *For the best pictures, kneel in front of your child so he walks towards you.*

As your child begins to walk and talk, a whole new realm of picture possibilities opens up to you. Picture them making mischief, playing happily with friends and passing the major milestones of growing up as they develop character and personality.

First steps Once your child has learned how to propel herself around the house, hanging onto items of furniture, you know she is about to take her very first wobbly steps.

Make sure you have your camera ready and loaded at all times over the next few weeks to be sure to catch the moment on film. For the best pictures, kneel on the ground some distance in front of your child, so that as she starts to pace towards you, you can catch that determined expression on her face – and catch her if she falls. Timing is everything, so wait till she has already managed a few steps before you release the shutter button.

Trap that toddler! Too many good pictures are spoilt because the child moves during the camera's exposure. Luckily, compact cameras are designed to freeze movement with flash when it is dark or with a fast shutter speed in daytime outdoors.

However, if your toddler is one of those hyperactive children who likes to get into lots of mischief all day, everyday, occasionally you will have to find some means of keeping her still for composed rather than

ABOVE *Use the camera's self-timer mode for pictures together.*

LEFT *Trap your toddler in her highchair so she cannot wriggle away!*

Camera Skills

■ This is how to take a self-portrait of yourself cuddling your toddler:

1 Set the camera on a small tripod so the lens is angled at shoulder or head height.

2 Switch the camera to its self-timer setting. This will give you a few seconds' delay before the camera's shutter opens and the flash goes off – just enough time to dash in front of the lens with your child.

3 Make sure you are directly in front of the camera and looking into the lens (or at your child) when the camera clicks/ the flash goes off.

4 Before taking the shot, remember to check the area in focus and make sure you have allowed enough extra height in frame so that you do not crop your head off at the top of the composition!

candid pictures! The technique of 'trapping' sounds cruel but is perfectly harmless. All you have to do is engineer some way of keeping the child restricted in one place while you take your pictures. For instance:
• after a bath, wrap your child in a big bath towel. This will help 'frame' her (drawing attention to your child within the broader picture area) and also has the bonus of keeping her arms and legs still for a few moments
• sit your child on a small stool behind a table with something new to play with. Take your pictures as quickly as possible, while she is engrossed

Do's and Don'ts

■ ABOVE When using flash indoors, don't set up the composition too near any interior walls. Instead, bring your child into the middle of the room to avoid harsh flash shadows.

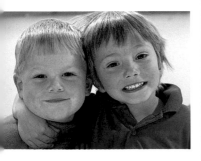

■ ABOVE For a picture of a young brother and sister, keep their heads close together in the frame so the background cannot be seen between them. This creates a more intimate portrait.

BELOW *Use a white bath towel as a framing device.*

RIGHT *Younger children are less self-conscious.*

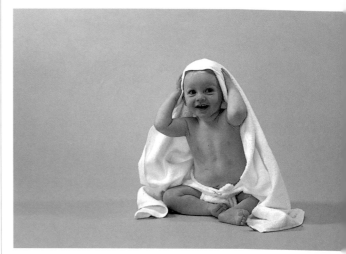

• swings with safety bars are also very useful when you want to keep your child secured in one place, and much more photogenic than a playpen indoors.

Playtime! Toddlers learn from play, and it is fascinating to watch them busily organizing their world. It is often best to simply sit back and observe your child, taking surreptitious pictures without intruding. You will find plenty of opportunities to take pictures while your toddler tackles colorful building bricks or plays with buckets and bath toys in the paddling pool.

Often, the younger the subject the more relaxed her response to the camera. For an older child (3–4 years), a fascinating new toy will help to achieve a genuine, unselfconscious expression. Once engrossed in the new toy, avoid distracting her with flash – use a faster film with a higher ISO rating (ISO 400–800).

The following toys are very useful, ideal for pictures where your child looks animated and interested in what she is doing:

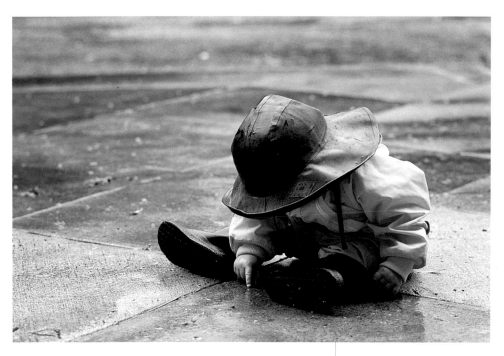

• a bowl of water and flour with a splash of food coloring – when mixed together this makes a cheap and colorful play dough
• a bottle of dilute dish detergent with a plastic hoop to blow bubbles
• plastic flower pots with a few marbles in them
• raw potatoes, cut in half and inscribed with letter shapes or patterns. These can be pressed into a saucer of paint and then onto paper to make pictures. Do not forget to protect your kitchen table and carpet with newspaper and to have your child wear an old apron!

Portraits Settle your toddler beside a window, 'trapping' her if need be with a chair and table. Use a plain background to avoid distracting attention from the child. If the walls or curtains do not provide a plain backdrop, a large sheet or table cloth, draped from the curtain rail or a bookshelf, will work just as well.

Picture Pointers

Nothing beats a natural giggle for picture appeal. Try one of these:

■ Hold the camera to one side, point the lens at her, then make a funny face, perhaps crossing your eyes and smiling.

■ Set the camera on a tripod, zoom in on her face and switch to self-time. This leaves you free to tickle her!

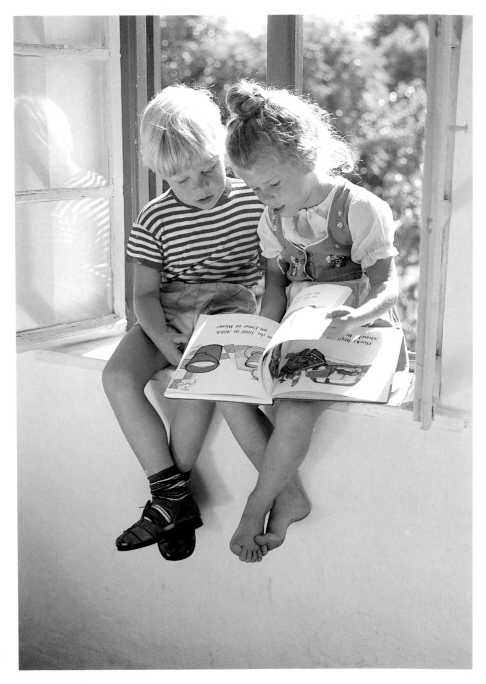

Use the telephoto end of your zoom to crop the portrait close around your child's head and shoulders. To keep detail in the shadow areas, switch your flash to 'fill in' mode, or else make yourself a small reflector from kitchen foil, to bounce the sunlight back onto her face from opposite the window.

Trouble Shooter

Q I would like to take pictures of my little girl blowing out the candles on her birthday cake. How do I set up the shot?

A If your camera allows you to switch off the flash, do so, as it is best to tackle this type of picture using available light and by investing in a small table-top tripod to hold the camera still. If you use the camera on autoflash mode you will overpower the candle flames, especially if the cake is to be brought into a darkened room. So, load up with a faster ISO film than usual (instead of ISO 100 use ISO 200 or 400) and position the camera on the tripod at one end of the table, looking up towards your daughter with the cake in front of her. Then, count to three and press the shutter button just as she puffs up her cheeks to blow.

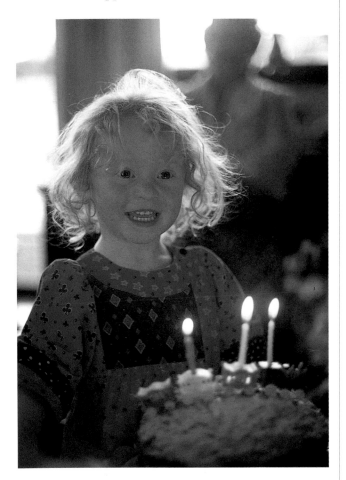

LEFT *Use window light to back light your children and a kitchen foil reflector to illuminate the shaded faces.*

ABOVE *With luck she will not blow them all out at once, so you will get several chances to get your picture.*

Juniors

The years from toddler-hood up to starting secondary school are filled with happy days spent playing with friends and developing a growing sense of independence. It is often hard to catch your children at home so make the most of those opportunities to follow your creative photographic instincts by setting up fun portrait sessions, one-to-one with your child.

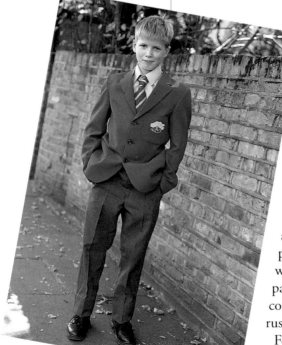

ABOVE *The first day in school clothes is too tense for photography. Set up the picture the day before school starts.*

Starting school A child's first day in school clothes is one to be cherished – it is about the only time he will ever enjoy wearing them! The best pictures are to be had as your child first tries the outfit on, perhaps the evening before school, when there is enough time for him to parade and for you to think about composition, without any pressure or rushing around.

For an interesting portrait, why not take a picture of your child admiring himself in the mirror with the new clothes all smart, clean and freshly pressed, buttons gleaming? This shot is easily set up, although there are three points to watch:
• check that your reflection does not sneak into the picture by standing just to one side of the mirror
• switch the flash off and use the camera on a tripod to avoid flare from the flash. Alternatively, a small piece of black card held to the side of the camera (between camera and mirror) should help direct the flash out of harm's way

• use the camera's focus lock to pre-focus at double the distance for a sharp reflection.

Weekend fun Once your offspring have started school, weekends, evenings and holidays will form the mainstay of any picture-taking sessions. Moments you will want to cherish will perhaps include:
• removing your child's training wheels from his bike
• the thrills and spills of roller skating
• building a sand castle at the beach
• learning to dive at the local pool
• picnicking at the park or barbecues with friends
• dressing up, face painting and play acting.
 Take your time with composition, perhaps using the wide-angle setting of your zoom to take a general shot of the scene, then zooming in for head-and-shoulders portraits, or a mid-range zoom setting for action shots,

Do's and Don'ts

■ For action portraits do adopt an oblique angle of view that shows roughly three-quarters of your subject.

■ Do try to tell a story with your picture, using props to show what the child was doing at the time. Wait for a look of glee, concentration or pride; anticipation and patience are needed.

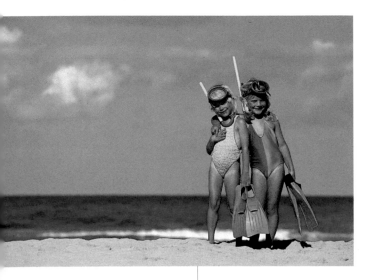

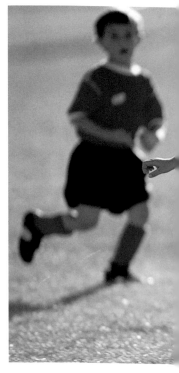

Picture Pointers

■ ABOVE Try to avoid framing a portrait so your child always occupies the center of the composition. To produce a more artistic and dynamic effect, position him to one side looking into frame.

■ If your zoom compact has autofocus, remember to use the autofocus lock to focus sharply on your child's eyes, then, gently holding the shutter button down without taking a picture, re-frame the composition to include more of the background.

RIGHT *Use your focus lock for off-center subjects like this striking image. The warm colors really capture the summer heat.*

throwing the background out of focus. If your zoom will not let you select a mid-range setting, move nearer or farther away from your child to secure the best overall composition.

When framing up any 'action' portraits, remember to include some of the contextual information in the picture. For instance, with cycling, include the bike or handlebars; for picnic portraits, frame loosely enough to show the food and outdoor setting; with sand castle building, use the bucket and spade as additional props.

Quiet moments It is not all high jinks for juniors – sometimes your child will want to sit quietly and read, try his hand at a spot of painting and drawing, or maybe just go fishing with one of his parents. To capture these more peaceful, thoughtful

Trouble Shooter

Q Why do all my portraits give the children bloodshot eyes?

A This problem is known as 'red-eye'. It occurs when the flash fires and illuminates the back of your subject's eyeball. Many compacts now offer 'eye reduction' – multiple flashes to encourage the iris to shrink before the main flash exposure.

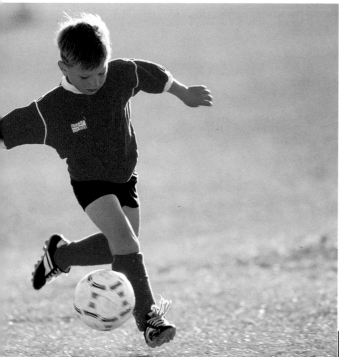

Juniors

Camera Skills

Try portraits with the sun behind your child. To avoid a silhouette:

■ Use fill-in or autoflash to light the child's face.

■ Use a foil reflector to bounce sunlight onto his face from the front.

■ Use the exposure compensation button to add detail in the shadows.

BELOW *An amber filter can 'warm up' a picture.*

BELOW *Backlighting requires gentle fill-in flash to illuminate the face. It can make all the difference to the final effect.*

RIGHT *Here the fence forms a frame that accentuates the child's face. Such frames within a frame give strength to a picture.*

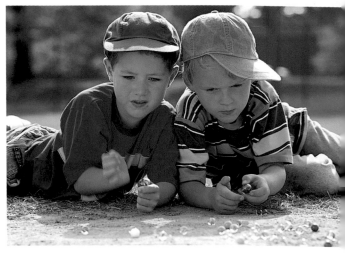

moments, it is a good idea to switch to a black and white film as this creates a more nostalgic, timeless look without the distraction of color.

If you would rather stick with color print film, try out a few subtle color filters to improve your results. For instance, an 81A warm-up filter (which is amber/straw-colored) can be attached over the camera lens using a couple of elastic bands. As its name suggests, this filter will literally help 'warm up' the sunlight, giving it a gentle golden glow that is ideal for sunlit scenes (without flash) indoors, and for autumnal portraits in the open countryside. Sepia filters are also available for more heightened warm-up effects – they can also improve a suntan!

When attaching the filter, make sure it covers the camera's light meter window as well as the taking lens, otherwise your shot will come out underexposed.

Framing A very handy compositional trick to add impact to your pictures is to use a 'frame' within the wider picture area. For instance, by positioning your child in a doorway or within the oblong created by a window frame, you are helping to underline his importance in the composition.

Try positioning your child so his eyes and nose are symmetrically framed by:
- a window frame – looking indoors or out
- the wide brim of a straw sun hat
- bubbles in the bath
- a doorway
- an arc of foliage

– it is surprising how much visual impact can be added to an image in this way.

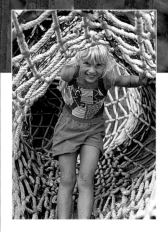

ABOVE *Climbing ropes can create a 'tunnel' effect that frames the child and leads your eye into the picture.*

Teenagers

As your children approach adulthood, they often pass through a difficult period when they strive for full independence from their family. It is hard to let them go, but in their own interests you know you must. Make use of the camera to record their youthful years at home, showing the full range of their school achievements, all those social activities and their favorite pastimes. Such a variety of intimate pictures will hold an enduring interest – not least for any new friends of the opposite sex!

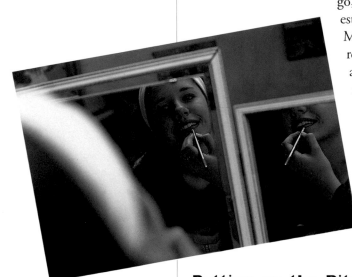

ABOVE *To secure a sharp image of a reflection, use the focus lock to set the focus at double the distance between your child's face and the surface of the mirror.*

RIGHT *Black and white prints make a stylish change from color for teenage portraits.*

Putting on the Ritz We can all remember getting ready for our first formal dance (or informal disco). It is a nerve-wracking process, but a great opportunity for girls to try out new make-up ideas and high heels, and for boys to 'strut their stuff', sporting the latest hairstyles and new street fashions.

If you would like to capture these self-conscious preening exercises on film, remember not to make fun of your teenager! Flatter her instead, explaining that you would like to take a portrait that conveys her looking her very best for the family album. Try not to interfere with the way she looks unless you want to provoke outright war – your daughter knows more about what is in fashion at the moment than you do!

If it is a summer evening, take the shot outdoors in the garden, using green foliage as a neutral backdrop.

Do's and Don'ts

■ Don't pursue a portrait session with a grumpy teenager who would rather be listening to CDs! Wait for a more relaxed moment.

■ Many teenagers are influenced by the current vogue for grainy black and white images on sale in high street poster shops. Do take advantage of this interest in photography, and load up with a fast ISO 800 or 1600 black and white film (but check your camera's DX-coding system is designed to cater for up to ISO 1600).

■ When choosing a setting for your portraits, do consult your teenager for her preferences. Fashion magazines exploit the strangest of locations – canal basins, scrap metal yards, yachting marinas and deserted railway platforms among them.

If it is a winter evening, you will have to use flash for an indoor portrait. Once she is ready, position your daughter slightly away from any nearby interior walls as the flash burst will cast a dark shadow on any surface which lies immediately behind her.

For shots of your teenager applying make-up in the mirror, it is a good idea to use a black piece of stiff card to shield the flash from the mirror surface.

Picture Pointers

There are two main approaches you can use to photograph teenagers with active outdoor hobbies such as walking, rock climbing, canoeing and horseback riding:

■ Get as close as you can to the action and zoom in to crop the composition tightly, at the same time retaining a small amount of space around your teenager to convey some of the outdoor setting and the give the picture context.

■ If your teenager is completely alone in the landscape, convey the sense of wide open space and freedom by standing back and using the wide-angle setting of your zoom lens, to keep the entire panorama in frame.

Team games Sporty youngsters provide their doting parents with hundreds of excellent photo-opportunities, provided the teenager does not mind if you attend every home and away game!

For action pictures showing your teenager with the ball, use the telephoto end of your zoom range. This will help you to isolate specific players from the edge of the football field or hockey rink. However, you will find most compacts are not designed for a great deal of magnification from a distance, so do not expect to get tightly cropped head-and-shoulders action portraits;

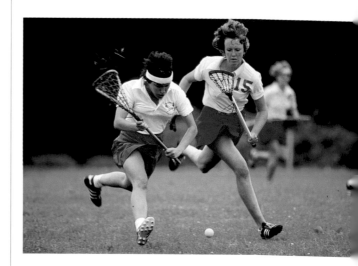

these can be achieved at the printing stage if you ask your processing lab to selectively enlarge the image around your child. In any case, you should manage to catch goal

ABOVE *Use selective enlargement to magnify the figures in action pictures.*

ABOVE RIGHT *Context is vital to some images.*

zone skirmishes and tackles using the zoom. If your child's team are favorites to win, stand behind the opposition goal post to catch that all-important winning goal: planning can make all the difference.

Trouble Shooter

Q After work and at weekends I sometimes assist the football coach at my son's school. I would love to catch his team on film as they mess around after the match. How should I go about getting an extra special shot?

A Schools often set up their own formal team portrait sessions, but as you are in the privileged position of seeing the players as they really are after a typical game, you are more likely to take the shot they will treasure long after they have left school. After a particularly muddy game, load up your camera with ISO 100 color film and invite all the youngsters to pull a silly face for the camera – perhaps posing in pyramid formation looking down at you from above to form a more dynamic shape than a straight-on regimented line-up.

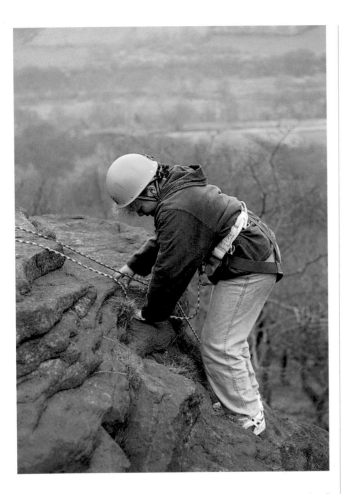

Skills and hobbies Keep a permanent record of your teenager's musical, dramatic and other hobby achievements. Although she may not appreciate your compositional efforts at the moment, she will look back on these youthful years at a later date and be glad of the pictures to complement her memories.

For skilled hobbies where creative handiwork is involved, take care to show what is being made, and ask your teenager to keep working while you frame up the picture. A wide grin into camera looks too artificial. Instead, vary your camera's position, distance

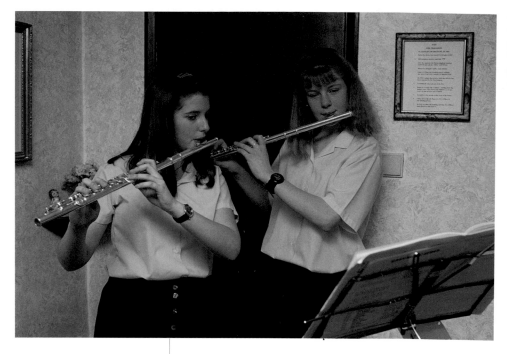

Camera Skills

■ In the hockey and football seasons, the afternoon sun is often particularly low in the sky. Choose which side of the field or rink to stand on before the game, bearing the lighting in mind: if the sun is shining behind your subjects, you will turn them all into silhouettes unless you use your exposure compensation button to help balance the exposure.

and height until you have gained a composition that shows your teenager's face (concentrating on the task in hand), whatever tools she is using, and the object she is working on. She may need to alter her position slightly.

ABOVE *Make sure the children are looking at the music for a realistic picture: it is best if they are actually playing!*

RIGHT *The wide-angle or panoramic mode will help show great open spaces.*

For hobbies involving a musical instrument, catch your child during a practice session seated beside a good-sized window, eyes wide open and looking at the music. For wind instruments, it looks more interesting if the child's cheeks are puffed up with air. For strings and percussion, try to show movement in the hand/bow/drum sticks by switching the flash off and placing the camera on a tripod.

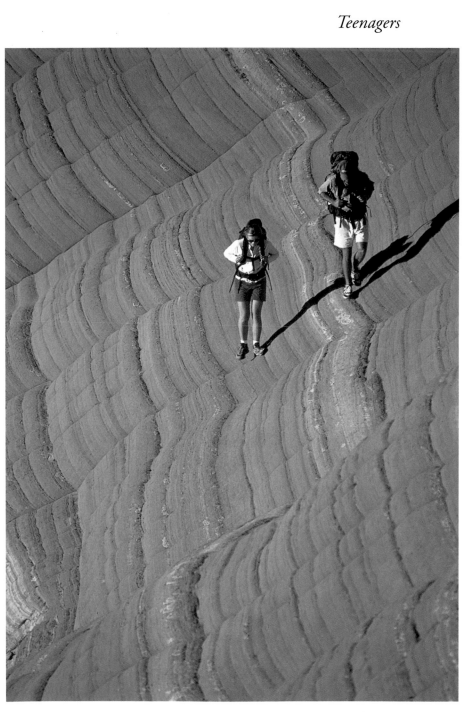

At Home

You do not need to live in a palace to take successful pictures of your children at home. It is often the case that the more homely and comfortable the house, the more relaxed the children!

Nevertheless, if the space is tidy you will find that there are fewer distractions in your indoor compositions. Messy piles of clothes and scattered toys and papers look jarring in a picture – crop them out of frame if you can!

Which room? Every home has a 'family room' where the children can play, read, do their homework, eat snacks and watch television. Although this is the place you will usually find the children for intimate and spontaneous pictures, it is not necessarily the best indoor venue for planned portraits.

For these you will need a spacious, light, clutter-free room with seating in the window area. The larger the window, the better – patio doors are perfect – as this gives you greater flexibility for taking subtle, available-light portraits without flash. A bright and tidy conservatory or sunny room is ideal.

The room does not need to be huge – just big enough for you to have sufficient distance between

ABOVE *Use a large window for fresh-looking portraits in natural light.*

yourself and your child to use the telephoto end of the zoom to isolate his upper body. It follows that the smaller the child, the smaller the room can be, but if you are after pictures of toddlers at play, remember you may need to 'trap' them in one place with intriguing toys on a low table (see Toddlers).

Using windows For the most natural-looking child portraits indoors, a large south-facing window is best, especially in summer when you will have so much sunshine you may even need to diffuse and soften the sunlight with the net curtains or a length of fine, light-colored fabric.

On an overcast or bright but rainy day, pull the net curtains back (or raise your blinds to uncover the window) as this will boost light levels. With the child seated directly beside the window, the sunlight shining in through the glass will help illuminate his face, to make it 'shine out' from its darker sur-roundings. In summer, if your child finds the light too bright, ask him to sit with his back to the win-dow instead, to stop him squinting. In these cir-

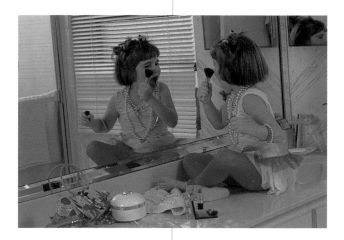

cumstances, you must remember to use the backlight control button to balance the exposure, otherwise you will accidentally turn him into a featureless silhouette! If your camera does not have a backlight control or exposure compensation button, simply switch the flash on to 'fill in' mode to record your child's face without running the risk of underexposure (results which are too dark).

Do's and Don'ts

■ BELOW Do watch out for the lurid orange color cast you get from domestic lightbulbs when using ordinary 'daylight-balanced' films. This is often masked by the flash burst and can be filtered out by your processing lab if you ask them to reprint the negative by hand.

Backgrounds While it might seem boring, look for simple, plain backgrounds for your portraits wherever possible. If your family room, bedroom and nursery color schemes are a hotchpotch of bright patterns and cartoon colors, take the child outdoors or into the kitchen instead. It may surprise you, but the plain, glamor-free geometry of kitchen units can make an excellent backdrop for home portraits of small children, simply because the units are unlikely to distract you from the subject's face. Remember, the idea is to let the child – not his surroundings – dominate the composition.

As a more professional-looking alternative for flash-lit portraits, draw the room's curtains closed, and if they are too 'busy' in design, scour the house for a sheet of plain cloth. This can be pinned or pegged onto the curtains, high enough up to keep the pins/pegs outside the viewfinder frame. Try:
• a plain, ironed bed sheet
• a large plain table cloth
• a stretch of neutral-toned fabric
• crumpled sail cloth canvas.

Picture Pointers

■ Many young children are keen to try baking and preparing food. In humid kitchens, watch that the lens does not steam up by keeping it in the warm to acclimatize.

■ For dim interiors your flash may be inadequate to light up the room. Some zoom cameras allow you to make 'flash and time' exposures, using flash to light the subject and a slow shutter speed to record the background. Otherwise, switch to faster film.

LEFT *With a plain backdrop, even the most untidy room can be used for professional-looking portraits.*

RIGHT *Junior cooks and chefs make excellent portrait subjects. Adopt a low angle to achieve eye-level results.*

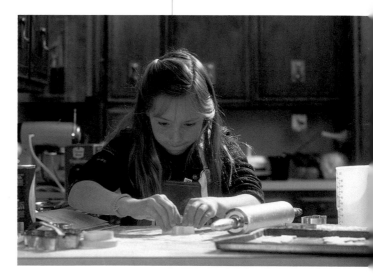

At Home

Camera Skills

■ Some compacts offer a 'TV mode' for shooting television screens. This automatically sets a slow shutter speed (usually around 1/30 sec) making the exposure long enough to avoid the horizontal bars that would otherwise interrupt the TV signal. Use a tripod as well when you photograph the children sprawled in front of the set.

■ Always remember that your camera is designed to measure the available light in a room scene, with a bias towards the center of the viewfinder. If the child occupies the majority or center of the picture area, the built-in meter will adjust the exposure to suit the child.

For best results, seat your child near the center of the room, then position yourself at the same height about 6–8 feet away, so that when the flash fires it will not cast a hard shadow from your child onto the backdrop.

Meal times Many young families are so busy outside the home that their main point of contact is the meal table. Thanksgiving dinner tends to be the favorite meal of the year, so why not commemorate the annual binge with a festive family-group shot?

RIGHT *In low light avoid camera shake by using a tripod and subject movement by using flash or fast film.*

Selecting the widest end of the zoom (to keep everyone in frame), put the camera on a tripod and use the self-timer button so that you can get in the picture too.

Take time to line up the picture correctly by peering into the viewfinder, perhaps raising the tripod on a pile of telephone directories. Finally, remember to check that glasses and crockery are not obscuring your children's faces. Ask the smaller ones to stand up and take a few different exposures of the same scene to ensure you have got one version where no one is blinking!

Trouble Shooter

Q My action portraits indoors always look a bit blurred. Why?

A This blurring could be either camera shake or subject movement. If the entire picture seems to blur in a uniform downward stroke it is camera shake. This occurs because the conditions are so dark the camera has selected too slow a shutter speed for you to hold the camera steady without jogging it as you press the shutter. Use a tripod or faster film. If the blurred parts of the scene are restricted to echoing the action, you know it is subject movement. Again, this is caused by too slow a shutter speed, but it is possible to freeze the action using flash.

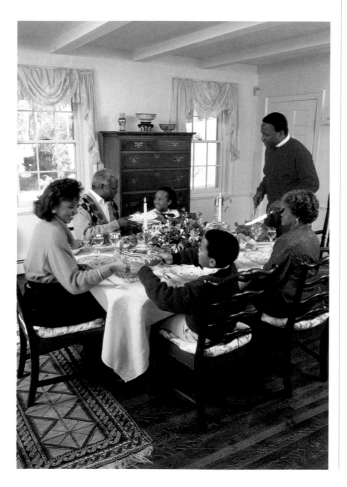

LEFT *For mealtime pictures use the wide-angle end of your zoom to include the full scene.*

In the Garden

Throughout the warm summer months, your garden is the ideal place to take pictures of the children. Even during spring and early autumn it provides a naturally light, sunny and colorful environment – a truly cheerful and colorful location that sets just the right mood for photography.

Shady ways On very bright sunny days it is best to take your pictures in the shade, avoiding extremes of contrast – very bright highlights and very dark shadows – especially if using slide films (for slide show pictures). Slow speed (ISO 100) color print films are more tolerant of a wide range of light and shadow in a composition, but for ease of metering, and to retain as much detail as possible, it is best to look for shade. To create shade have your child:

ABOVE *Reduce contrast by introducing shade into your portraits, such as the brim of a sunhat, here making a glowing halo.*

- sit cross-legged under a tree
- laze beside a large bush
- crouch under a parasol on a rug
- grin out from under the brim of a large sunhat.

By avoiding high contrast and using natural shade you can even up skin tones and actually improve color saturation.

Water fun If it is very hot outdoors, drag the sprinkler, water hose or wading pool out onto the lawn to set up pictures of your children enjoying watery antics in their swimming costumes. There is no better end to a hot, sticky day than a quick dash or two through the water hose – and your flower beds will doubtless benefit too!

For spontaneous shrieks and giggles, be ready with your camera the minute the action starts. Use a waterproof or splashproof camera if you have one, or else keep a disposable splashproof compact ready to hand in the kitchen drawer. If you do not have a waterproof camera, a clean transparent sandwich or freezer bag is a useful means of keeping the worst of the wet off your camera's delicate mechanical parts.

Picture Pointers

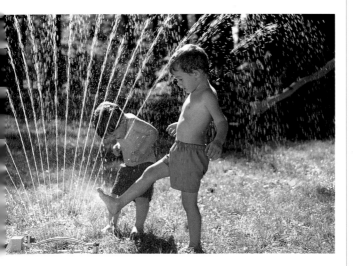

ABOVE *Keep your camera dry inside a plastic bag when taking watery pictures.*

■ ABOVE Choose a neutral green backdrop, unless the color of the floral display harmonizes with your child's clothing.

■ Do not take pictures in noon sunlight as it creates dark shadows around your children's eyes. Wait for the late-afternoon light instead, but if the sun is low take care not to let your own shadow spoil the picture!

■ Set a small plot of the garden aside for your child to tend. Apart from the enjoyment this can bring, it will make an excellent picture project.

Camera Skills

■ For fresh-looking, high impact garden portraits, think of alternative camera angles such as from an upstairs window.

■ Most camera meters are designed to darken light-toned scenes automatically, to make them more balanced. To retain the sunlit highlights, try taking one picture as recommended, then, if you have an exposure compensation mode, take an identical shot at '+1'.

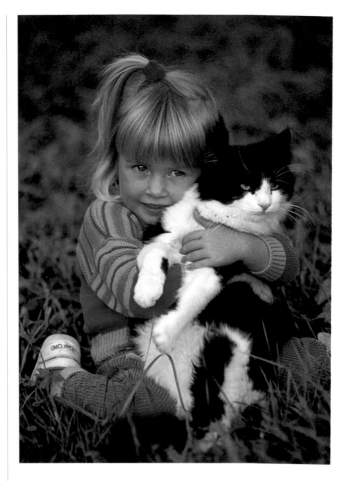

Pets If you adhere to the age-old saying: 'never work with children or animals' you will miss out on some of the most endearing picture opportunities to be had in a garden setting.

To keep the animal action within the viewfinder, have your child crouch on one knee to hug and stroke the pet, then kneel down at the same height to keep the child's head at eye level. For a less static approach, get her to bounce a tennis ball for your dog, using the normal fixed focal length setting (typically 35mm), panorama mode or the widest end of your zoom.

Natural framing Trees and other garden foliage (such as the branches of shrubs) can be used to create a frame within the wider picture frame, helping to isolate and draw attention to your child. For instance, if she is climbing the lower boughs of a tree, it is possible to frame the shot from a particular angle (perhaps from below) to make the trunk and branches form a natural frame for her. For subjects seated in the middle of the lawn, try taking your pictures through a gap in the branches of a neighboring tree, taking care not to let any fronds or leaves obscure the view.

Shrubs and even tall flowers (eg delphiniums and foxgloves) can be used as a frame in a similar way. Get near to them, so they are just inside your closest focusing distance – this way they will form a slightly out-of-focus blur at the picture edges.

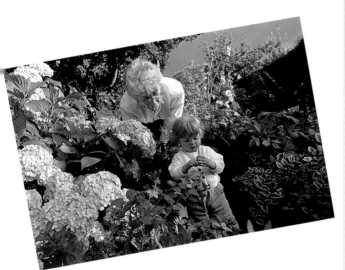

ABOVE LEFT *Get as close as you can to fill the picture area for a print with real impact.*

ABOVE *Be sure to show your child enjoying the garden with other members of the family.*

Trouble Shooter

Q What is the best way to pose groups of children for natural-looking pictures in the garden?

A The best advice is to avoid boring, over-strict regimentation by introducing a more dynamic arrangement. Use interesting shapes and body angles wherever possible and link the group together (for instance, by having the children grin at one another, link arms or point at an object one of the children might be holding). Try positioning the group so that the children's heads are all at different heights. You could have the tallest child seated on a low wall, the shortest child standing just behind, two crouched on either side and another lying in front on the ground. For some reason, odd numbers seem to look better than even numbers – but no one should be left out just to satisfy this quirky fact!

At the Park

BELOW *Make use of the telephoto end of your zoom to isolate your child at the top of a slide.*

Afternoon trips to the local park are a prime opportunity for you to take pictures of the children playing. Although you have to supervise toddlers closely, there will be useful moments when you can stand back from your child to take your pictures. Arrange a visit when the sun is not too high in the sky or too bright, as you will get dark shadows in your child's eye sockets. Bright but overcast conditions are best.

On the slide Depending on the age of your child, sit him at the top of the slide and crouch at the bottom with your camera, calling words of encouragement and beckoning him to push himself down the slide. Press the shutter as he gets half way down, preferably with a big grin on his face!

If you find the timing too difficult, wait till he is right at the bottom so you can look up the slide and use it as a 'lead-in' line, directing the eye to the child at the bottom of the picture. Older children might like to perform more exciting slide stunts such as going down the chute head first, waving from the top or posing halfway down.

Swings Keeping track of your children can be tricky if they would rather be up and off! A good way to trap them in one place is to tuck them into a safety swing, behind the bar, so they cannot move.

Take your pictures while you push them, waiting for the forward movement of the swing before taking the shot as this will ensure the child's face is not overshadowed when the sun is out. Again, older children can pose in a more adventurous manner, working themselves higher and higher without your assistance, perhaps even jumping off at mid-swing provided there is a soft landing and you are not standing in the way! Freeze the moment with flash, making sure to release the shutter button at the very height of the jump.

ABOVE *In overcast conditions it is possible to blur action to convey movement. Use a slow film and switch off your flash, but use a tripod to avoid additional camera shake.*

At the Park

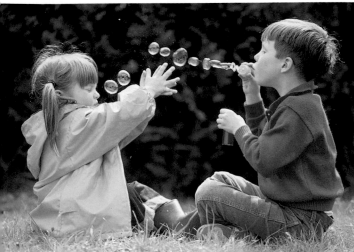

LEFT *Adopt a low camera angle to fill the frame at eye level.*

BELOW *A safety swing will keep your hands free for photography.*

RIGHT *Time your picture carefully to capture the most exciting moment.*

Picture Pointers

■ Bright red garments are great for creating color contrast with the green surroundings at the park, although if children are wearing too many bright clothes you will notice the clothes and not the children!

■ On a rainy day, take along a colorful umbrella as a prop and make the most of the reflective qualities of the puddles.

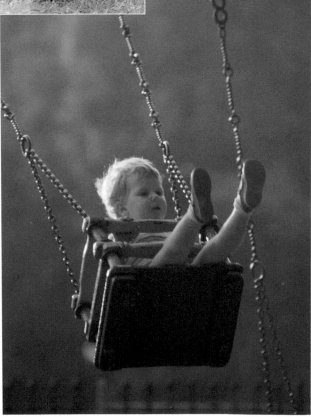

This is the ideal opportunity to use 'flash and time' mode if you have it. Here the camera chooses such a slow shutter speed for the exposure that after the flash has fired to freeze action, the camera's shutter stays open long enough to record blurred movement afterwards. Part of the image will be sharp, part will be blurred, adding a sense of movement and excitement.

Climbing trees Some parks have a good range of solid trees, such as oaks and horse chestnuts. Let your youngster tackle climbing them both to improve his

Do's and Don'ts

■ Do use a fast ISO 400 film to help you freeze the action at the park on a dull day. Your camera's built-in flash will not be sufficient to light the whole park.

■ Ducks and swans make an elegant addition to your child portraits at the park. Do remember to take a bag of stale crusts with you to lure the waterfowl to the lakeside, and wait till all the ducks and swans are looking at your child before taking the picture.

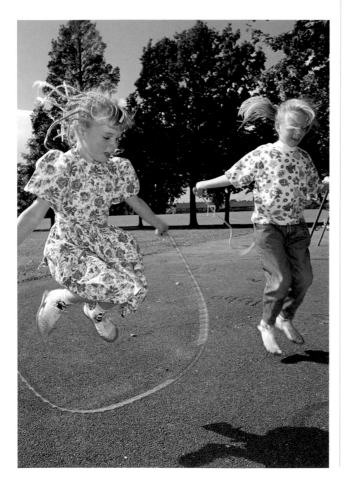

Trouble Shooter

Q How should I photograph my ten-year-old doing cartwheels?

A Stand close by as your child performs his acrobatic feat, kneeling down at the last minute to frame the shot from a low angle. Or, put the camera on a tripod and release the shutter by remote control, taking advantage of its self-timer.

co-ordination skills and strength, and to lend him a sense of independence. Trees make an ideal natural frame within a photo portrait – once the child is happily and safely seated on a very low branch, stand back a little so the tree boughs and foliage surround him. Stay fairly close for reassurance and to make sure the child is not 'lost' within the composition.

Playground antics Occasionally you will have access to your child's playground at school and, of course, there is the playground at the local park. Both venues are great for action portraits using the camera's flash and fast film as means of isolating and freezing the moment on film.

BELOW *Think of unusual camera angles for a more striking result. Try using climbing bars to frame your child's face from below.*

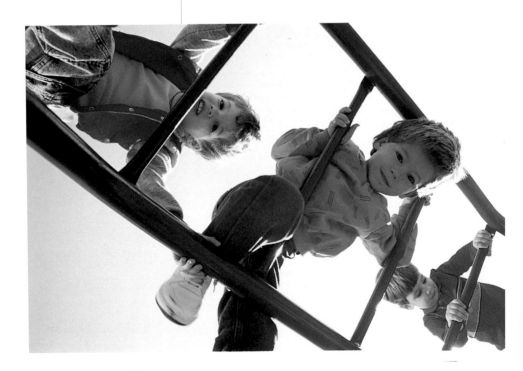

• Climbing frames – use the climbing structure as a frame within the wider viewfinder frame, adding impact to your child's face as he peers through the gaps at the camera.

• Skipping ropes – use fast film and auto or fill-in flash to halt the action on film, and take care to time your picture to coincide with the moment your child jumps into the air for a more exciting pose.

• Skateboards – adopt a low angle close to the ground but looking up at your child, and use the widest of your zoom settings. If you have a fixed lens with a focal length of around 38mm this is ideal. Even if he is just posing for you to take a picture, have him bend his knees to look as though he is moving.

BELOW *With a slow shutter speed you can pan with the action to blur the background but keep the skateboarder sharp.*

Camera Skills

■ Try not to let the right-hand side of the camera twist down as you press the shutter. This is one of the most common causes of camera shake.

■ If your camera allows you to switch off your built-in flash it will almost certainly select a slow shutter speed (ie longer exposure); it helps to use a tripod in such circumstances.

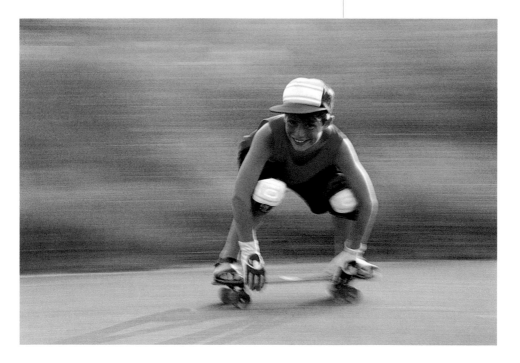

Festive Fun

Everyone loves a good party! Family and friends put chores aside and get together to have fun playing games, dancing, eating and drinking. Whether your party is just for children or for a wider age range, make sure the camera is ready and loaded, with a couple of spare films tucked safely in your pocket.

Wedding celebrations You will not want to miss pictures of the children at a wedding: it is a rare opportunity to get shots where they all look clean and presentable – at least until the reception, that is! Young toddlers and juniors love all the dressing up and party food, especially if they have the honor of being bridesmaid or page boy for the day.

Lower your vantage point for candid pictures of your children in their wedding day outfits at the church,

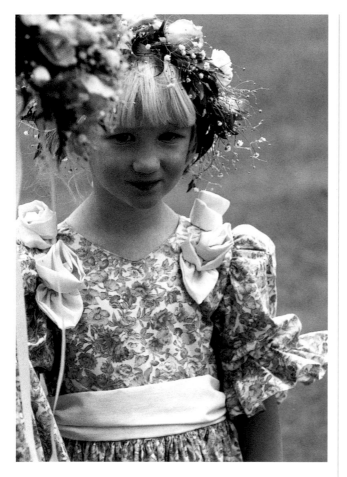

Camera Skills

■ To draw greater attention to your child at a crowded birthday party, use the telephoto end of your zoom when composing the portrait. The background and foreground will be thrown out of focus as they are outside the band of sharpness.

perhaps switching off the flash for a more surreptitious approach. Wait for thoughtful, pensive poses and be quick about lining up and taking the picture. It is a good idea to wait until the reception before grabbing these candid pictures, as the children will be more settled after they have had something to eat. Save some film for the dancing too!

Disco parties Even if you do not know your hip hop from your foxtrot, discos and parties are a great place for pictures of youngsters enjoying themselves.

The colored lights and rhythmic movements make for excellent candid pictures of teenagers dancing, drinking and socializing with their friends.

However, discos are not a great place for parents and grandparents to start getting the camera out, so if you are hosting the disco at home, make yourself scarce in an upstairs room with the portable television – although you may not be able to hear it!

Instead, leave a disposable compact with a built-in flash in the hands of your teenager, encouraging her to get lots of action-packed, atmospheric pictures you can

Do's and Don'ts

■ ABOVE Do be careful when using flash in very dark rooms as the light will not be powerful enough to illuminate the whole area. Use a faster film speed.

■ Do photograph your child in a shady area to stop pale-colored clothes looking dull as the camera tries to compensate for bright sunlight.

■ RIGHT Don't forget to turn your camera 90° to the vertical position for 'tall' portraits.

all chuckle over in the morning! Warn her that:
• the flash will not be powerful for large group shots at a distance
• she may have to keep at least one yard away from her subjects for the fixed focal length lens to focus
• she needs to take care not to crop any heads off with parallax error (see Jargonbuster).

Garden parties In fine weather, there is nothing better than a birthday party outdoors. For really good pictures on a bright summer's day, set up a buffet table under the shade of a tree and sit alongside with your camera on a table-top tripod to avoid camera shake, switching the flash off. Otherwise, set it to 'fill in' mode to keep the attractive surroundings correctly exposed, but avoid having hard sunlight bearing down on the children as they come to choose something to eat.

Vary your compositions by occasionally turning the camera 90° into a vertical position. Portraits taken

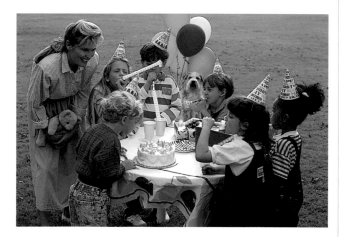

ABOVE *Make sure you can see all the children's faces in a group portrait around the table.*

Trouble Shooter

Q When I use my compact's flash mode for party pictures indoors, I sometimes get a blurred after-image. Why is this?

A This is a common enough phenomenon – known as 'flash blur' or 'slow synch flash' – and it is often exploited at parties for unusual special effects that convey both body movement and colorful party lighting. It occurs when the camera selects too slow a shutter speed for the correct fill-in flash exposure. Usually in fill-in flash mode the camera adjusts the flash output according to how bright the available light is. In full sunshine there is no problem. However, when the light is dim there is a fair chance that the shutter speed will be so slow that once the flash has fired and faded, the shutter stays open long enough to record subject movement recorded on film by the ambient daylight or party lights.

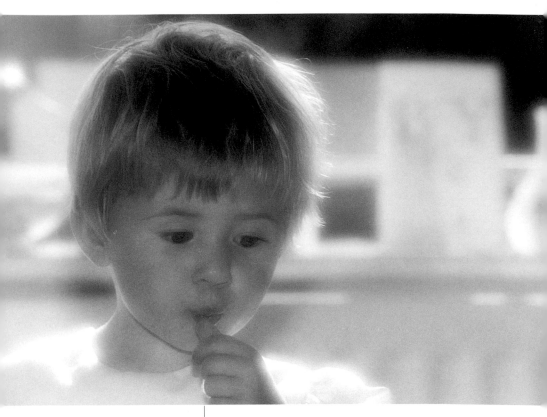

Picture Pointers

■ ABOVE For a special party image, try using a soft focus or starburst filter, taking care that you cover the central picture-taking lens.

with the camera upright like this will fill the picture area more effectively. For informal groups of two and three, turn the camera back to the horizontal, get as close as your minimum focusing distance allows and avoid gaps between the children's heads.

Choosing the right film It is not always necessary to stick with ISO 100 color print film for all your children's party pictures. Indeed, it is important to match the film to the particular party conditions, perhaps keeping a couple of extra films of faster ISO speeds to hand.

If the party is held indoors with the main tungsten room lights switched on, you will find your results

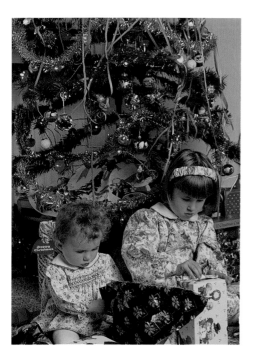

come back with a distinctive orange color cast. To avoid it you have three main options:
• use a special tungsten-balanced color slide film (there is no tungsten-balanced color print film on the market at the moment). You can always make a slide show of the results.
• use a fast color print film (eg ISO 400) and a blue color correction filter over the camera to balance and counteract the orange. Note: this reduces available light and any flash-lit pictures will come out blue, so keep the flash switched to 'off'
• use a color print film and ask the lab to enlarge your favorite prints, filtering out the orange.

Summer parties outside are a far easier proposition. You can use your ordinary ISO 100 color print film without fear of a color cast and you can use flash to freeze any running around – and there will be a lot of that as the excited children make the most of the event.

ABOVE *Tungsten room lights record orange on ordinary print film. To avoid this have the negatives hand printed so the orange can be filtered out. Otherwise, use tungsten-balanced slide film.*

At the Beach

Whether you live inland or near the shore, a day trip to the coast is packed with picture potential. Do not miss the opportunity to take pictures of your children gleefully frolicking in the sunshine, swimming in the sea, skimming stones across the surface of the water and burying each other in the sand.

Jumping the Waves Paddling and splashing about in the sea can be great fun, but there is one major pitfall with pictures of this sort. All too often the picture-taker is stranded on the beach while the children

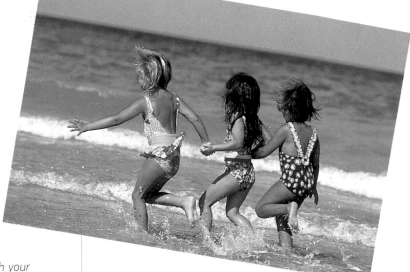

ABOVE *Catch your children frolicking in the surf with the camera at its zoom-in telephoto setting.*

wade farther and farther away from the camera. Use a zoom or, better still, switch to a single-use waterproof camera for the day, which will allow you to wade in after the children. Time your pictures for when the waves lift them bodily up off the bottom, otherwise you will lose them in the swell.

Sunset silhouettes At the end of a fine summer's day there is usually ample opportunity for sunset pictures, showing your children playing on the beach in silhouette against a vibrant red and orange sky. If you take the time to plan the picture in advance you will pick a west-facing spot looking out across the beach towards the horizon and open sea.

These sunset silhouette photographs are a lot easier to take than you might think, simply because your camera will be tricked by the bright horizon into underexposing the children in the foreground – thus removing any detail by turning them into black shapes isolated against the colorful sky. All you have to do is switch the flash off and lean against something solid to keep the camera steady. A tripod will help if you can wedge it firmly into the sand. Adopt a low angle to better isolate the children's bodies against the sky.

As a last resort, if the sky turns bland and overcast, there are sunset filters on the market that can help you fake the effect for quite natural looking results!

Do's and Don'ts

■ Do keep the children covered in suntan lotion for happy faces without lobster-colored skin!

■ Don't put your camera into a bag with a wet and sandy beach towel. Sand will scratch the lens and salt can damage the camera's internal workings.

■ BELOW To enhance a natural suntan at the beach, do slip an 81A or 81B warm-up filter over the camera lens.

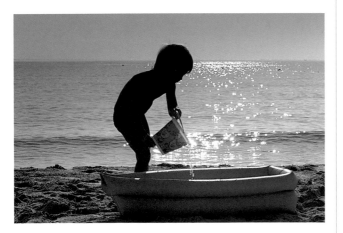

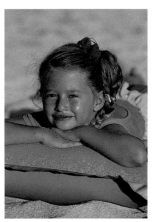

ABOVE *Point the camera at the bright sky or water highlights for a silhouette.*

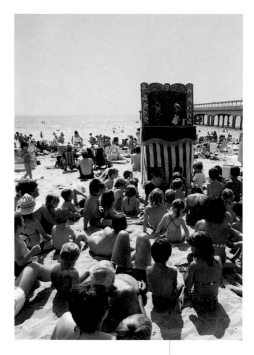

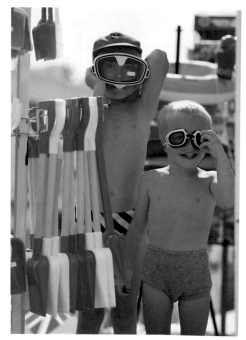

ABOVE *For general scenes like this, try positioning the main focal point off-center.*

ABOVE RIGHT *Stalls along the seafront are an excellent source of impromptu props.*

Seaside attractions Piers, funfairs, beach performers and donkey rides are all part and parcel of the seaside experience. To avoid stiff and humorless portraits of your children taking part in such activities, let them wander on ahead to explore at their own pace, and keep the camera in standby mode so you are ready for any spontaneous laughter.

• If you are on a pier looking out to sea over ornate iron railings, try positioning your child about two thirds of the way into the frame, using the railings as a lead-in line pointing to him.

• With a cluttered stand of hats or sunglasses outside a tourist shop, get your children to pose for you wearing a few of the samples for comic effect.

• Why not get your children to sit on a pair of deckchairs side by side looking out across the beach. Frame the shot from behind the chairs so you can see their silhouetted shapes as shadows.

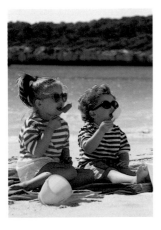

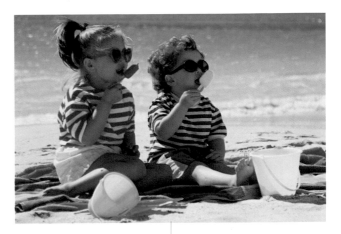

ABOVE & ABOVE RIGHT *Try both vertical and horizontal formats; the effect can be quite different, even with the same subject.*

BELOW *This composition is marred by the bleached-out colors. Bright highlights have led the camera to overexpose the scene.*

Picture Pointers

■ When photographing your children sunbathing, avoid the easy framing option of taking the picture from their feet looking upwards. With a fixed wide-angle lens this will elongate their legs and shrink their heads.

■ Use the longer telephoto end of your zoom range to crop beach portraits tightly, moving away from your child until the image is within the focusing limits of your camera.

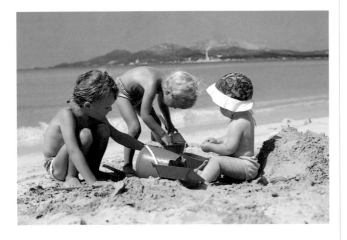

Sandcastles You do not need to be an expert in medieval fortifications to rustle up a quick sandcastle! However, where pictures are concerned, beware the changing tides and changing position of the sun. To

Trouble Shooter

Q When I tried to get a shot of my child peering into a rockpool, you could not see the fish for the reflection of the sky. How can I overcome this?

A Polarized light creates reflections on water so you need a circular polarizing filter, held over the front of your lens and rotated 90° against the polarized light. The filter will cut through reflections and reduce the available light by up to two f-stops. To compensate, use your exposure compensation dial and add extra exposure (+1 or +2).

keep as much detail in the castle as possible, you will have to angle yourself so the sun shines across the castle without catching your own shadow in the composition, then get the children to pose proudly alongside their creation.

One more thing to remember: if the children are not occupying the center of the composition, use the auto-focus (AF) lock to pre-set the focus on the children's faces, then re-frame the composition so they are just outside the middle of the picture area.

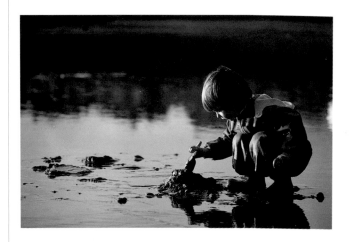

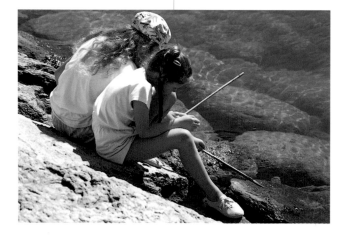

ABOVE *When the subject is off-center, use your camera's focus lock.*

LEFT *A circular polarizing filter will help you cut through water reflections.*

RIGHT *If the sun is harsh and directly overhead, a parasol will reduce contrast.*

In the Country

BELOW *Use the breathtaking scenery as a backdrop for your child portraits.*

Getting out of town for the day makes a refreshing break for everyone, whether it is a quick trip to the nearest stretch of greenbelt or farther afield, into the deepest heart of the countryside. Look out for waymarked public footpaths, picnic spots and Pick-Your-Own farms as these are all exciting picture venues. A farm holiday or weekend break near a National Park can give a really healthy boost to your family album.

Using the scenery

Take advantage of those beautiful grand vistas by setting up portraits of your children arranged in an artistic, natural fashion in front of them. Wait for a spell of good weather, then use the low-angle of morning or late afternoon sunshine for softly lit and warm-toned holiday portraits.

However, do remember that it is all too easy to try and cram everything into the same picture without assessing

Do's and Don'ts

■ Sailing and fishing activities can lead to perfect waterside portraits, especially at dawn or sunset. Take advantage of the attractive lighting conditions, interesting cloud formations and colorful skies at these extremes of the day.

ABOVE *Think of ways to link the children with their setting, such as getting them to sit together, fishing from a jetty.*

RIGHT *If your family goes horseback riding, try to keep ahead and use the wide-angle setting for results that are sharp throughout.*

■ If your children are horseback riding without you, head for a high valley slope where you can get a good vantage point over the trekking party and the scenery around them. Use the panoramic mode to show the horses against the horizon.

whether each part of the composition actually makes a positive contribution to the end result. Spend time thinking about what it is you like most about the view (is it the little green boat moored on the shore, the cloud pattern, the mountain's reflection in the lake or the neat line of trees that leads to the horizon?) then set about isolating that feature through your choice of viewpoint. It may be necessary to turn the camera into a vertical position to crop out unwanted features.

In the Country

Picture Pointers

■ BELOW For portraits of your child with a wild or farm animal, choose a low camera angle, check the background for clutter and pick the right focal length of your zoom.

Once you have arranged your country backdrop, checked the corners of the frame for stray litter and have selected the wide-angle end of your zoom (which will allow you to keep more of the scene sharp from front to back), you can now invite your child into the composition. Try:

• Positioning your child in the foreground to one side of the shot, within the lens's minimum sharp-focusing distance, looking into the picture area at the splendid view beyond.

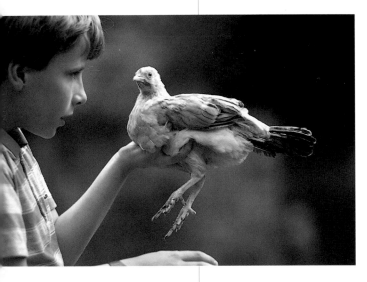

RIGHT *Backlighting leads to beautiful countryside scenes like this. If your camera offers backlight control or exposure compensation, dial in +1 stop.*

• Asking her to move farther away from the camera and deeper into the scene. You could get her to pose by leaning over a bridge, crouching on a rock overlooking a stream or leaning against a tree. Such poses will give the picture a more dynamic quality.

Children and animals All year round, our National Parks are positively teaming with wildlife, from rabbits and squirrels to butterflies, wild horses and even deer. It is very difficult to stalk such creatures for portraits with your children, although in autumn

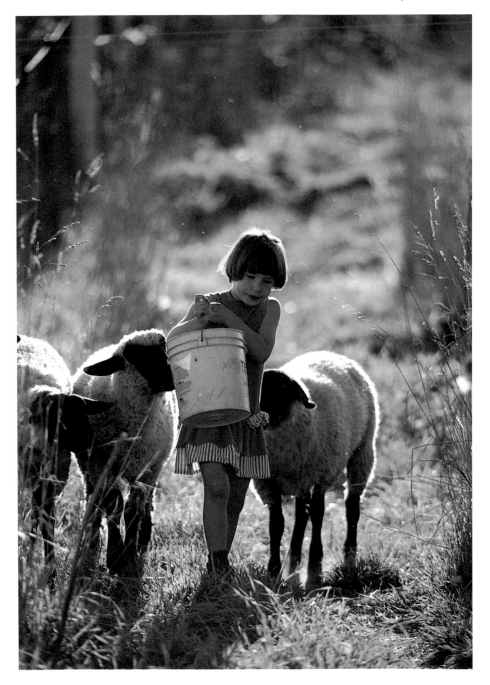

Trouble Shooter

Q Are there less cumbersome ways of keeping the camera still than using a tripod?

A Yes, here are some:

■ BELOW Rest the camera on something solid with a light-weight beanbag underneath to stop the camera wobbling.

■ Practice tucking your elbows in, standing with your weight evenly balanced, then hold your outward breath as you release the shutter.

■ Brace yourself against a tree or a sturdy fence.

■ Choose a slightly faster film for the day.

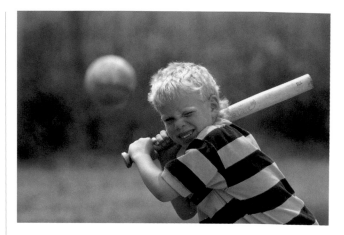

and early winter it can be easier to attract the tamer garden species (eg robins and squirrels) with offerings of their favorite food – berries, nuts and seeds.

On the lower slopes of hills and lush valleys you often find horses, cows and sheep grazing near small farmsteads. These animals can be camera shy too, but a handful of grass or a piece of fruit might coax them to approach. But do not feed any farm animals along the roadside as this encourages them onto the road.

So, if you are staying on a remote farm or in a wooded campsite on holiday, have your children scatter bread for the wild birds and hold out peanuts for the squirrels. Use the focus lock (or 'trap focus') facility to focus on your child's outstretched hand, and be ready with your camera for the moment the animal reaches to take the food.

Picnics There is nothing better than a picnic to create a sense of fun in your pictures. Once everyone has a plate of food and a drink, take out your camera for a group shot. Stand back and use the wide-angle end of your zoom, but make sure the group occupies 50 per cent of the frame. A hint of the green, outdoor location is usually sufficient as a visual scene setter.

LEFT *A fast film will help you freeze the action without the aid of flash.*

RIGHT *Use the camera's self-timer for family shots including yourself. Fix the camera to a mini-tripod for sharp results.*

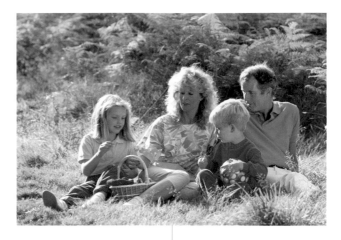

Frisbee, softball and football provide more scope for candid picture-taking. Resist joining in until you have a shot that shows the children taking part – you will have to stand up and move to a position that shows the pitch, zooming in to isolate your child as she leaps to head the football or takes a swing at the softball. A fast film will ensure the action is frozen on film without the need for flash.

Bad weather We have all suffered the bad-weather-blues at some time; there is nothing worse than being trapped indoors in the middle of nowhere with a family of listless children, desperate to go out and play. So, rather than let the rain get them down, why not get them to dress up in their wet weather clothes (did anyone bring a snorkel and flippers?) and take a series of comic pictures in the rain.

If you do not own a water- or splash-proof compact, simply slip the camera inside a clean, water-tight plastic food bag and pull the plastic tight across the lens to keep the camera free to focus. In a steady downpour you will have to keep wiping the bag to avoid rain drops showing as mysterious blobs in your pictures. In really dull conditions use ISO 400 film and flash.

Camera Skills

One of the most creative portrait techniques to master involves altering the area of sharp focus. This area is known as the depth of field.

■ To increase depth of field, switch to a fast ISO film (ISO 200 or 400), use bright conditions, select the wide-angle end of your zoom or increase the distance between your child and the camera.

■ To decrease depth of field, switch to a slow ISO film, use shade, select the telephoto end of your zoom or get closer to your child.

Funfairs and Fireworks

Roll up, roll up!
Get those film rolls loaded!
Few places are as colorful and cheerful as the fairground at carnival time, where balloons bob among the stems of pink cotton candy and fairy lights delight and dazzle the eye. Fairground rides will whisk your squealing children off their feet, and at night time colorful firework explosions can really set a thrilling note of movement and drama.

Fairground attractions At dusk you will be able to get some super high impact pictures using the 'flash blur' or 'slow synch flash' technique. This entails loading a slow color print film (ISO 50 or 100) into the camera and then setting the flash to its 'fill in' mode. As it is dark at dusk, the camera will

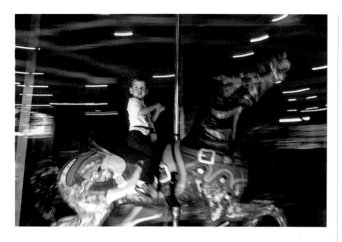

ABOVE *With the camera on a tripod, switch the flash off and use ISO 100 film to show fairground movement.*

BELOW *The attractions of the fair include sweet, sticky eatables – the perfect prop for comic candids like this.*

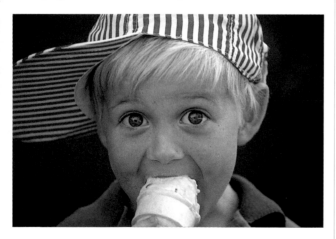

select a slow shutter speed for the fill-in flash exposure, which means that while the (very fast) flash burst will arrest the action sharply on film, the shutter will stay open afterwards for long enough to secure a 'ghost image' recorded by the dusky daylight, conveying the trails of movement. The

Trouble Shooter

Q My camera lacks a 'time' or 'bulb' facility but it does have multiple exposure mode. Is this any use for firework shots?

A You will find that using the multiple exposure (ME) button is an excellent way of lengthening the exposure for night time firework pictures. Pressing the ME button prevents the film from winding on after one exposure is made, so that the subsequent exposure can be superimposed over the dark areas of the first picture. For firework double exposures simply take one shot of the explosions in the sky, press the MF button to disengage the film advance, and take a second shot (on the same film frame) showing your child lit with fill-in flash. The best combinations are made when one image is light in tone (the flash-lit child) against a darker one (the night sky with fireworks).

Funfairs and Fireworks

Do's and Don'ts

■ When composing firework pictures, do use the wide-angle end of the zoom as this makes it more likely that the fireworks will arc into the sky and explode within the picture frame.

■ Don't take your firework or fairground pictures with the camera handheld as you will blur the results unless you are using very fast film (eg ISO 6400).

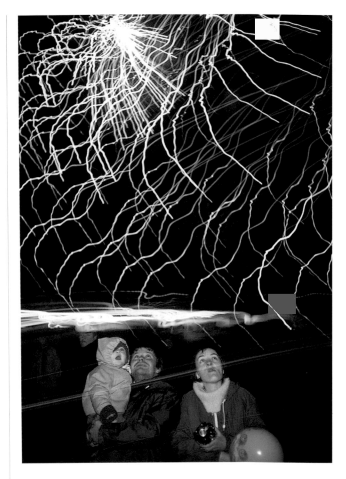

ABOVE RIGHT *Fill-in flash will attempt to balance the flash on the foreground with the available light behind, while autoflash will yield a more powerful burst. Try both to see which effect you prefer.*

best rides for this are those that travel horizontally, directly in front of the camera position (for example, bumper cars and carousels) rather than those that take off on more complex paths.

During long time exposures, if you have a zoom on your camera, it is possible to move it through the full zoom range, creating a zoom burst. This is ideal at fairgrounds as it blurs the edges of the frame to create a dizzying tunnel of color, while at the same time keeping your child, who must be in the center of the frame, relatively sharp. Ideally, use a tripod.

Firework explosions Many of today's more sophisticated compacts offer a facility called 'time' or 'bulb'. These are excellent features to find on a small camera but they do tend to push up the price. In creative terms they are certainly worth it.

The 'bulb' setting allows you to make what are known as 'time exposures' which record very low light scenes at night, such as illuminated landmarks and Christmas lights, without the risk of underexposure or garish flash spoiling your picture. To use these features, all you have to do is put the camera on a tripod or wedge it against something solid (a beanbag on the bonnet of the car is ideal) and press the shutter release to start the exposure. Unlike ordinary picture-taking, you can keep your finger on the button and time the length of the exposure using the second hand of your watch or by counting the seconds.

'Time' exposures are similar, although here you can actually take your finger off the shutter button during the exposure. Pressing it a second time will stop the exposure but, again, you must count the length of time the shutter stays open. For either technique, it is best to invest in a special cable release adapter to trigger the shutter as touching the camera body risks jogging it.

For firework pictures that also show your child, follow these steps:

1 Load up with slow film and brace the camera securely (a tripod is best).

2 Use the wide-angle setting of the zoom lens and point the camera at the section of sky where you expect the fireworks to go off.

3 Switch to 'flash and time' (or 'bulb', using a torch to light your child's face, otherwise she will become a silhouette).

Camera Skills

■ BELOW If your autofocus system has trouble keeping track of a moving fairground ride, switch to using the focus lock/trap focus facility instead. Keep your finger gently on the shutter release until your children swirl and spin into frame – then smoothly press the shutter button down.

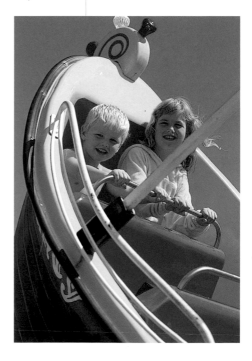

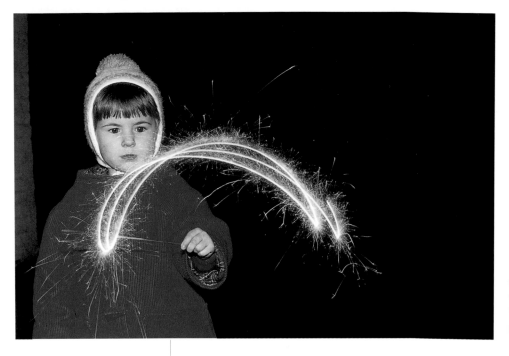

Picture Pointers

■ ABOVE Sparklers are great fun for portraits on July Fourth. To record their light trails use a tripod and slow film. If you have a 'time' or 'bulb' mode, select it and count the exposure out as the child spirals the lit sparkler within the composition area. Without 'time' or 'bulb', simply let the camera select its slowest possible shutter speed.

4 Trigger the shutter button. An exposure time of between 10 and 30 seconds should suffice for the fireworks in the background.

5 Vary the length of your exposures, holding the shutter open and counting the fireworks as they explode. Because the sky is dark there is little risk of overexposing them, although, if you are using 'flash and time' mode, watch that the flash lighting your child does not overpower the scene behind .

6 Try not to get too many fireworks in frame as it makes the sky look too tangled: four large flares is plenty. Adopt a low vantage point looking up at your child and the sky behind, or stand her on a wall/sit her on the roof of the car if she is very short.

Theme parks For a complete change of scenery, pop along to your local theme park and head for the water rides, or to a roadside water chute.

These make for exciting pictures so it is worth getting really close to the pool (if safety permits) with a waterproof, splashproof or single-use compact. Wait for your children to descend the chute at speed and let the flash freeze them in mid-air or, on a water ride, catch the water as it arcs into the air around them. A small scrap of chamois leather will help you dry the droplets off the lens afterwards.

In a Disney theme park, track down some of the over-sized characters and get your children to pose with them. Introduce humor to your compositions: show your child offering Mickey some ice cream; ask Mickey to crouch down for a kiss; buy your child some Mickey Mouse ears so they look alike!

BELOW *Use flash to freeze the action as your family is jettisoned from the water chute.*

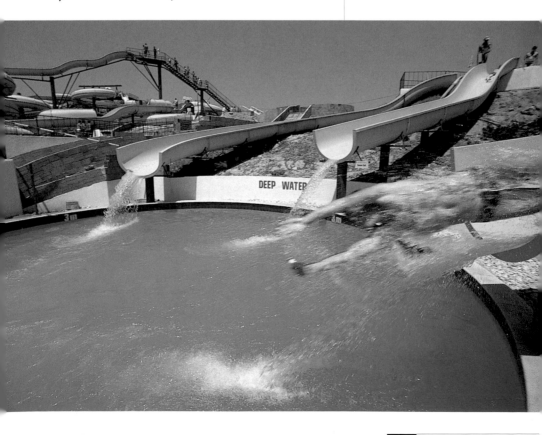

Sports Day

ABOVE *Teenage sport is fast and furious. With slow ISO 100 in the camera you may well capture blurred limbs, which can, of course, look effective.*

What better opportunity than the school sports day to take pictures of your children joining in the fun? Catch them racing around, jumping and leaping hurdles, putting new athletic skills to the test and taking on an active team role with their friends.

Securing a good view One of the main tactics for good sports portraits is getting a good view. Even the longest telephoto setting will not assist when your child is running a race on the opposite side of the athletics arena! Plan your picture-taking positions as you would a military campaign; get there early and secure a ringside seat. A tripod will help mark out your territory, although for some shots you will need to be more mobile.

For straight lane races (such as the egg and spoon event, hurdles or 100 meters dash), adopt a position as close to the end of the course as possible, near the outside lane, to get a good three-quarter view of all the competitors. Crouch for a low angle to avoid the distraction of spectators' heads and ranks of advertising hoardings.

If the sky is particularly bright, take care to dial in an extra stop of exposure compensation (eg +1), or else use your camera's autoexposure (AE) lock to pre-set the exposure. This involves taking an initial

Do's and Don'ts

■ Do contact the head coach and/or gym teacher to let them know you would like to take a few pictures for the family album. They might allow you special access to training sessions where it will be easier to go onto the field or race track.

■ Don't forget to practice the panning technique (see page 74) at home, with your child riding slowly past you on a bicycle. The movement is slow and smooth like a golf swing.

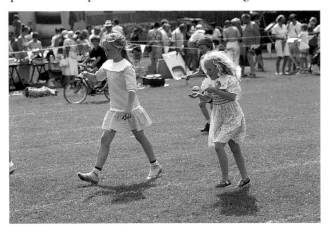

ABOVE *Beware backlit races: use flash or add one stop of exposure compensation to avoid silhouetting.*

RIGHT *Include all the competitors in some pictures, to show your children in context.*

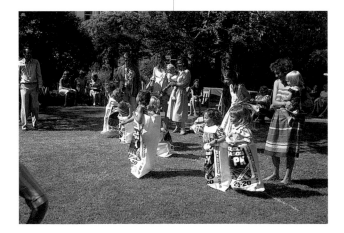

Picture Pointers

■ The direction of action in a sports event should influence the way you tackle it. For example, if the action is crossing in front of you, your camera will need to select a much faster shutter speed to freeze the action than it would if the action were approaching you head-on.

ABOVE *Get to know your children's favorite sports; it will help you to anticipate the action as they play and to catch them at their best.*

light reading by pointing the camera lens at the grass, then holding your finger gently on the shutter button as you re-frame the composition to include the children against the sky. This will help you avoid turning the racers into silhouettes, especially if they are backlit.

For field events such as the javelin, high jump and, for younger children, 'Tossing the Ball', safety will dictate where to stand. Keep as close as possible but remember to use the wide-angle setting if you want to show where the javelin/ball lands.

Using flash The best way to freeze fast sporting activities on film is to use fill-in flash. Provided the day is bright and sunny, or you have a fast film in the

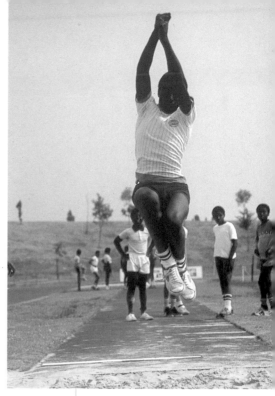

camera (eg ISO 400), 'you will have few problems isolating and lighting up the sporting contenders mid-action with the flash burst.

Pre-focusing For straight lane races with teenage competitors, the action takes place pretty fast so you will have to set the focus point in advance. If you are standing by the outside lane around the finishing line, you could try pre-setting the focus using your focus lock (or 'trap focus') facility if your camera has this option. To use the focus lock, simply focus on one of the white lane marking lines about a quarter of the way down the course (around the 75-meter mark in a 100-meter race), hold the shutter button down to lock the focus, then raise the camera to re-compose at the correct camera height for the competitors. As the leading runner races into view, press the shutter button down and most of the competitors should be sharp.

ABOVE *With field events the zoom facility comes into its own.*

BELOW *As the race nears the end, stand behind the finishing tape and pre-set the focus to a point just beyond it.*

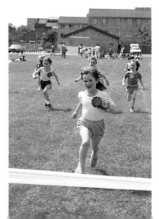

Camera Skills

■ Getting razor-sharp results is largely a matter of understanding how your camera is going to react to the conditions. For instance, in dull autumn weather, you will have to use flash and a fast film speed, which means you will have to wait for close-up action within the flash's range.

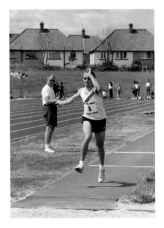 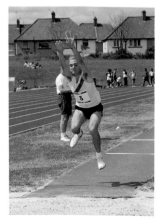

Panning Sharply focused sports portraits are fine, but they lack the drama you would get if you allowed a small degree of movement to blur part of the composition. Panning is a technique whereby you can keep the child running sharply across the composition but with an effectively blurred background and blurred legs to show how fast she is running.

To use this technique, load up with a slow ISO 50 film or wait for a dark cloud to pass over the sun, then:

1 Stand parallel with the race track, legs planted apart, weight evenly distributed, and perhaps using a monopod to lend extra steadiness to the camera.

2 Switch the flash off to make the camera select a slow shutter speed of 1/30 sec or slower, (depending on the amount of sunlight and your film speed).

3 Wait for the children to race into the far side of the viewfinder frame.

4 Gently release the shutter and (while the shutter

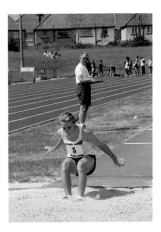

LEFT *If your camera has a sequential action mode (ie takes a series of rapid-fire pictures), use it to capture the long or high jump.*

BELOW *For poolside pictures, time your shot to coincide with a breathing stroke so you can see your child's face.*

Trouble Shooter

Q What is the best way to tackle swimming races?

A Your best approach is to ask the marshals if you can crouch by the poolside during your child's race, then to use the wide-angle lens setting (perhaps with fast film in the camera if you cannot use flash). Pre-set the focus on one of the floats marking your child's lane. Hold the camera in a vertical position for a more dynamic picture shape and angle the lens downwards at the pool surface so most of the frame is occupied by the pool. If the water is bright with glinting sunlit highlights, it is wise to dial in an extra stop of exposure compensation. Check that the lens does not have water droplets on it when you take the picture as these will distort the image.

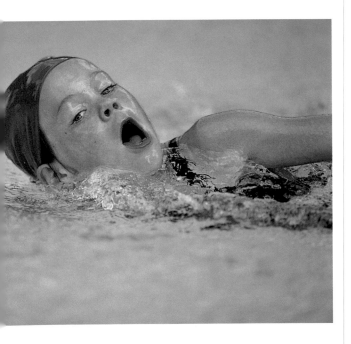

is open, during the exposure) smoothly move your camera – and your entire upper body – to follow the children's movement.

The result should be an image showing the children in focus while the background is blurred.

Performing

Learning lines, auditioning and being picked to take part in the annual school play is a real thrill for children of all ages. So, even if your youngster is only a sheep in the infants' nativity play or has a small walk-on role wearing a tomato costume, you will still want to record his 15 minutes of fame on film! Here is how to take shots that turn your child into a real star...

ABOVE *Wait for a significant – and still – moment for best results.*

Lights, camera, action! One of the first problems to bear in mind is the fact that school budgets rarely extend to a decent stage lighting set up, so you will have to invest in some fast color or black and white print film for the evening, say around ISO 1600 to 3200 if your DX-coding system stretches this far – otherwise use ISO 400 and wait for your child to move into a bright part of the stage.

Your flash will not be powerful enough to light up all the people on a large stage, and you may get that ugly bleached out look where the children nearest to you are lit too brightly while those farther away are

Camera Skills

■ More sophisticated compacts have 'DX-code override' buttons which allow you to 'uprate' the film, making it more sensitive to the available stage lighting. The processing lab will need to know the new ISO speed; the results will be grainier than usual.

ABOVE *Knowledge of any choreography will enable you to time shots perfectly.*

BELOW *The ballet class is an intimate setting, so be discreet with your camera.*

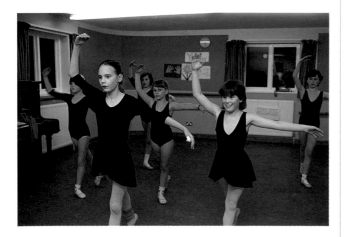

cast into a pit of darkness. This is known as flash fall-off and it shows how the camera's built-in flash sensor will assess the scene to light up the middle part correctly, overexposing anything that lies closer and underexposing anything that is too far away. For these

Picture Pointers

■ BELOW RIGHT
If you are able to shoot the action during a dress rehearsal, ask the stage manager if you can bring along a box or small step ladder into the seating area to photograph the stage from a more elevated level.

reasons it is best to avoid flash, relying instead on the meagre spotlighting system of your school hall for gentle ambience, an ultra-fast film, clever anticipation of a halt in the action on stage, and a good tripod to avoid camera shake.

Using the dress rehearsal If you must use flash, use it wisely and use it at the dress rehearsal – not the main performance. This way it will not be so critical if one of the children forgets his lines after being startled by a sudden burst of light. To get the most from your built-in flash unit, load up with a fast film and wait for your child to come near you at the front of the stage, ideally standing stock still for a few seconds and filling the picture area as much as possible. Use fill-in flash mode if you have it – this will allow the flash sensor to measure how much light it needs to emit to light your child correctly.

Rehearsals are useful for two other reasons:
• if you do not want to use flash you will be able to assess the general stage illumination from a lighting rehearsal. Find out who will be lit brightly, and when, so you can make full use of strong spotlights

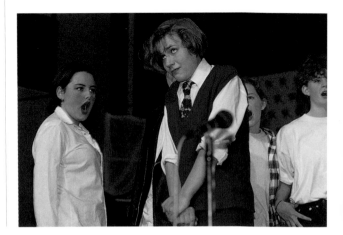

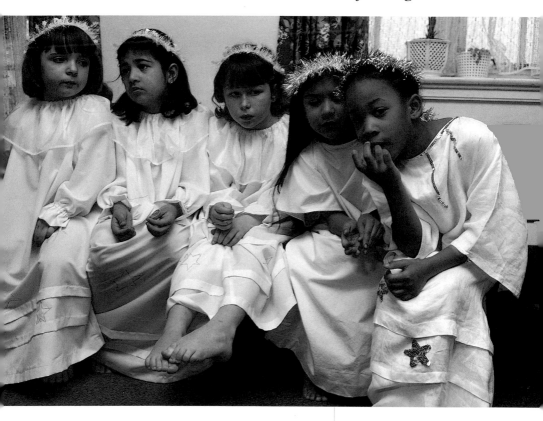

ABOVE *If possible, take pictures behind the scenes, to catch that air of high excitement that surrounds a performance.*

RIGHT *With off-center framing you may need to use the focus lock facility to focus and re-frame the composition.*

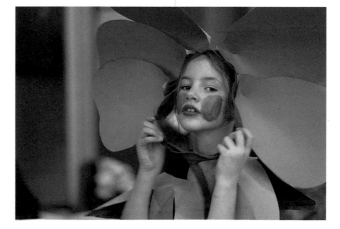

Performing

Trouble Shooter

Q I want to take pictures of what goes on behind the scenes to put a play together. How should I go about this?

A You could start off by concentrating on the children as they get into character, showing aspects such as line-learning, practicing new dance steps and trying on costumes. Include the set builders, painters, prop people, musicians and anyone else in the team. Technically speaking, the main pitfall is likely to stem from lack of light. Ask the school's head lighting technician to turn up the lights to full power during your picture-taking sessions on stage, and load up your pockets with lots of fast ISO 400 film (or faster if your DX-code range goes up as far as ISO 3200). A tripod will help keep the camera steady to capture make-up sessions.

• you can use rehearsals to watch your child's performance in full, learning his lines and movements so you can judge where you will need to stand to take your pictures when he is in costume.

Conveying the drama Every play has a peak in the drama. If you have been attending some of the rehearsals, you will probably know the cast and plot already. If your child has a particularly poignant line or action to perform, make sure that this is the shot you catch on film. Time your picture to show the dramatic ex ssion on his face, and if the lighting is particularly moody at that point, make sure the camera is on a tripod to avoid a poor, blurred result.

TOP RIGHT *Take a wide-angle picture of the full cast, arranging them so that the tallest performers stand at the back.*

RIGHT *Stage footlights are rarely adequate for picture-taking. Load up with fast ISO 1600 film if your camera's DX code system goes that high.*

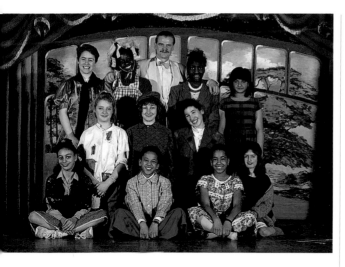

Do's and Don'ts

■ Don't use flash at young childrens' performances. They may forget their lines and be very embarrassed.

■ Do arrange with the director to take a formal group portrait of the full cast after the last performance or dress rehearsal.

Winter Action

Do's and Don'ts

■ If you can, do use a waterproof compact for action on the slopes. Snow and cameras don't mix well!

■ In extremely cold weather, your camera's batteries will give up. Do save them by switching the power off when the camera is not in use. You may find the battery-powered flash takes longer to recycle too.

RIGHT Children love the snow; look for an angle with a neutral backdrop to really concentrate on their glee.

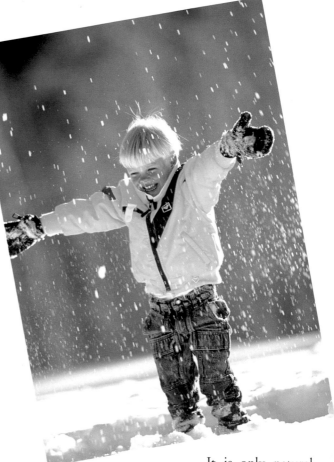

It is only natural for children to want to get outdoors as quickly as possible after a snowfall, to run around, build snowmen and throw snowballs, and all of these activities can make excellent photographs. Crouch low, use fill-in flash to freeze action, and enjoy!

Tobogganing Even the smallest children will enjoy sliding down a gentle slope with their bottom on a tray! To capture the sense of movement, use a

RIGHT *Adopt an eye-level position if possible, especially after tumbles.*

BELOW *Wait until the snowman is complete for the best record.*

Camera Skills

Try to avoid the sparkling octagonal hotspots symptomatic of lens flare:

■ For backlit scenes, shoot with the sun cropped right out of the picture area.

■ Make your own shield or lens hood from thin cardboard tubing.

■ Keep the sun behind or to one side of you when you line up your picture.

panning action to hold the children sharp in frame, blurring the snowy background at the same time. Select a slow film speed in dull weather and let the camera select a slow shutter speed (around 1/30 sec). During the exposure, follow their movement smoothly, while holding your breath and bracing your arms against your body to avoid camera shake.

Skating Ice rinks can get a little crowded for picture-taking. To isolate your child as she manoeuvres

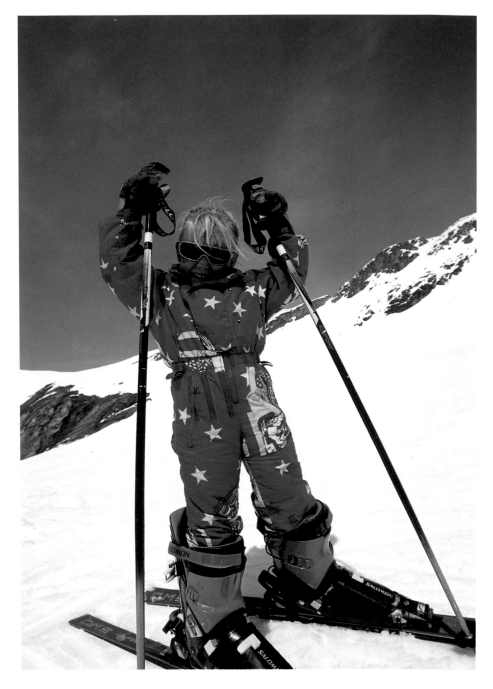

LEFT *The wide-angle lens setting is tremendous for dramatic distortion. Shoot against the sky for a bold blue and white backdrop.*

RIGHT *Stand back and wait for a moment when the slope is free of other people: early or late in the day is best.*

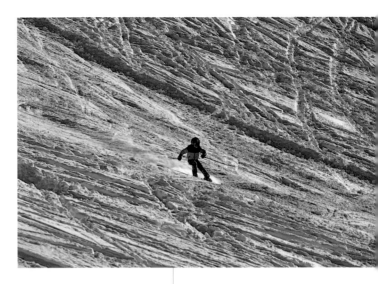

around the rink, stay safe and steady at the ringside. Use the telephoto zoom setting to enlarge her in frame as this will automatically reduce the depth of field (zone of sharp focus) within the image, concentrating attention on your child, not the skaters surrounding her. If she comes close enough and takes a tumble, use the fill-in flash setting to arrest the flying limbs!

Skiing For amusing pictures of the smallest children taking part in their ski-school classes, stand at a distance just to one side of the slope and wait for their instructor to lead the whole class downhill, snaking along in a snowplough formation. Use the telephoto setting to crop out the bustling nursery slopes.

If you are an experienced skier yourself, you have an excellent advantage in that you can freely follow your children around while they are being taught to ski, keeping at a distance to avoid putting them off. Capitalize on their colorful ski outfits against the snow by shooting in good weather, taking care you do not include the sun in the frame as this will cause flare spots on the prints.

Trouble Shooter

Q Why does the snow always seem to come out gray or blue rather than brilliant white?

A This is caused by the camera's built-in light sensor which automatically selects settings which will darken the snow to a less dazzling tone. Either dial in an extra stop of exposure compensation, or slip a sheet of gray card in front of the lens just before taking the snowy shot and use the autoexposure (AE) lock to hold this neutral reading.

Pose, Clothes and Props

BELOW *A play area full of plastic balls makes for a cheerful picture; it also helps to 'trap' your child.*

To gain full creative control over your child portraits, it is best to plan the picture-taking session in advance, making sure there is plenty of time to set up and that your child is in a relaxed and co-operative mood. Teenage subjects can be most difficult; ask them for their own image and styling ideas and help get them into the posing mood with a few of their favorite cassettes playing quietly in the background.

Location

First of all, choose where you want to set up the picture. Be adventurous, but avoid places where the setting will compete with your child. For a teenage-fashion look, try the local junkyard or abandoned building, using the peeling

paint, rusting cars or textured stone as an interesting but relatively neutral backdrop. For younger children, use dappled sunlight in the garden or at the park, and, at the beach, use shapely dunes to convey the seaside theme. Babies and toddlers can be 'trapped' in the wading pool, in a swing with bars or in a baby bouncer – options which allow you to concentrate on composition without worrying about their safety or enjoyment as you *do* want to catch them at their best.

Picture Pointers

■ If you are focusing close to fill the frame with your child's face, a hat will help create a frame within the wider viewfinder frame to draw greater attention to your child.

■ Use filters to create extra mood and drama – a sepia, warm-up or full-frame soft focus filter are all ideal for romantic sunlit scenes, and if there is water in frame, use a starburst filter to exaggerate the highlights.

ABOVE *Props and toys will keep your child amused while you concentrate on composition.*

RIGHT *For off-center framing you will need to use the focus lock. The results will show the setting while making for a pleasing, eye-catching picture.*

LEFT *Vary the child's stance and pose from one shot to the next; if you put in the imagination, you are more likely to achieve a beautiful portrait like this.*

RIGHT *Fancy dress makes for comic compositions. Keep a hamper aside for dressing-up clothes.*

Trouble Shooter

Q How can I build a rapport with my teenage nephew to be able to take pictures of him in a relaxed mood?

A A good child photographer often needs to be something of a psychiatrist! Before you even start thinking about taking pictures, you will have to work out what makes your nephew tick: is it rock music, computer and video games, films, girls? If he is the silent type, you may have to consult his parents and any co-operative brothers and sisters. Then think of a way to introduce this passion into the portrait session. For example, allow him to play his favorite tapes during the shoot, encourage him to pose in his favorite clothes, or ask him to show you how his video games work, then take the session from there.

Posing With slightly older children – juniors up to teenagers – it is possible to ask them to vary their poses to keep them from getting bored and, more importantly, to introduce variety from one picture to the next to ensure at least one flattering combination.

There are several variables to alter:
• stance – sitting on the floor cross-legged (trousers only!); sitting with both legs to one side; sitting on a chair; standing; standing leaning against a wall or tree
• head and shoulders – these can be arranged at different angles to the camera
• eyes and direction of gaze – looking left, right, straight into the lens, up or down
• hands – the fingers look best when angled naturally into a curl. Avoid tightly clenched fists and floppy hand gestures
• chin position and camera height – with the camera on a tripod it is possible to vary camera height in relation to the subject's head.

Dressing up Clothes are a vital aspect of portraiture: they act as a form of visual shorthand that can speak volumes about the child and his personality. They can also help to convey a unifying visual theme.

Pose, Clothes and Props

BELOW *A set of face paints will add color and interest to a picture; they will also engross younger children completely. Use the bold effects imaginatively.*

For example, children who participate in group activities such as Scouts and Brownies can wear their uniforms for a group photograph. This co-ordination will give the picture much more of an impact than if they are wearing a great variety of colors and patterns. (Such photographs will make good mementos for them all.) Restricting the palette will also ensure that you look at the children in the portrait – not at their outfits.

However, there is one notable exception. Old-fashioned adult dressing-up clothes can lend a sense of comedy to a portrait, especially if the child is very small and the clothes are obviously too big. Keep a hamper filled with your more outrageous fashion mistakes as these will create hours of fun for the children and many hilarious photo opportunities for you. Scour secondhand clothing stores, jumble sales and charity shops for:

Camera Skills

■ To take pictures of your child admiring his reflection in a mirror, you may find that the camera focuses on the mirror surface and not the image reflected within it. Use your focus lock to focus on something that is about the same distance away as the reflection, then re-frame the image.

- wide-brimmed floral hats
- old spectacles (without the lenses)
- colorful strings of hippy beads
- waistcoats and gaudy neck or bow ties

Top up your child styling collection with a set of face paints and amusing wigs.

Toys and props To complete the portrait composition you may find it necessary to give your child something to do or hold, especially if he is young and has a short attention span. Use a dough mix (water, flour and a few drops of food coloring) or

plastic flower pots to keep young toddlers amused. In teen portraiture, props can have a more significant role to play than merely keeping the youngster occupied. You can use props to communicate something about the sitter (he loves surfing, is a keen tennis-player and so on); or they can help convey a particular mood – simply by switching the accessories you can introduce an entirely different feel to a picture.

Do's and Don'ts

■ Don't skimp on film if you want to get a shot that is worthy of an enlargement up to 8 × 10 inches for framing.

■ If you are thinking about shooting on private property for your location portraits (eg a cornfield, the fountains of a stately home) do ask for permission in writing first. Explain that you are an amateur photographer after family portraits but that you may wish to use a tripod too.

ABOVE *A three-quarter-view portrait is best with larger toys which give added depth to the picture.*

RIGHT *Simplicity is the key to impact in child photography. Do not overload a scene with too many props.*

Jargonbuster

APERTURE: this refers to the opening inside the lens which lets light through to reach the film inside the camera. The size of this opening is varied automatically in most compact cameras, according to how much light is available. For dark scenes the camera will select a larger aperture to let sufficient light through onto the film to make the correct exposure. Aperture sizes are measured in f-numbers.

AUTOEXPOSURE: this is the system which allows the camera to control exposure automatically. The camera's light-sensitive circuitry is able to measure the amount of light reflected by the scene in the viewfinder and thus evaluate the shadows, mid-tones and highlights to choose average exposure settings in the split second as you release the shutter button.

AUTOFOCUS: this is the system which allows the lens to focus on the subject automatically, using either an infrared beam or image contrast to dictate where the precise point of sharp focus lies. Focusing accuracy is governed by the number of set focus positions available, known as focusing steps.

BACKLIGHTING: an attractive form of portrait lighting where the main light source is shining towards you, from behind the subject. Requires careful light metering to avoid turning the subject into a silhouette – use fill-in flash or a reflector to bounce light back from the front.

BULB EXPOSURES: the 'B' or 'bulb' setting is available on certain top-of-the-range compact cameras. This allows you to make manually timed exposures (with the camera on a tripod for best results) showing full firework explo-sions and the colorful trails created by traffic headlights as they move past.

CAMERA SHAKE: this occurs when the camera moves during an exposure and is most commonly caused by accidental jogging as you press the shutter button, or through body movement such as breathing. In dull conditions your camera may select a shutter speed that is too slow for sharp results; in such cases, use a tripod.

COLOR CORRECTION FILTERS: indoors you may like to try holding an 80A (blue) color correction filter over the camera lens and light sensor to counteract the orange color cast which occurs in tungsten lighting.

DAYLIGHT BALANCED FILM: ordinary films are balanced to a color temperature of 5500K. This means they will give neutrally-toned results in noon sunlight, but when the color temperature is lower such as at 3200K (ie the colour temperature of domestic tungsten lightbulbs) the results will appear orange.

DEPTH OF FIELD: this is the band of sharp focus in a picture surrounding the focused point selected by your AF (autofocus) sensor. It is possible to exploit depth of field to turn a portrait background out of focus – select the telephoto end of your zoom and lock the focus on your subject's eyes. Telephoto lenses are designed to give shallower depth of field so the background will automatically go out of focus, especially if it lies at a great distance from your subject.

DOUBLE EXPOSURES: many compacts offer either a multiple exposure (ME) or double exposure facility. First you take one picture in the normal way, but if you press the ME button,

the camera primes the shutter for a second shot without winding on to the next film frame. Most of the best double exposures combine one bright image with a dark one.

DX-CODING: the computerized system inside the film loading bay at the back of the camera that reads the film speed and number of exposures available automatically.

EXPOSURE: the process of recording an image from life onto a light-sensitive surface, such as photographic film. Photographic exposures are created using a camera with a shutter and an aperture. These limit the amount of time allowed for light to reach the film.

EXPOSURE LOCK: the camera feature which allows you to hold and lock one light reading in the camera's memory while altering the composition. This is useful in conditions with high contrast, as you can take a light reading from a neutral-toned area by pointing the camera at it, lock this reading into the memory, and reframe the shot to the more contrasty scene.

FILL-IN FLASH: the flash mode designed for use in bright sunshine which allows you to add a small blip of light into shaded parts of a scene without overexposing the image.

FILM SPEED: the ISO rating of your film refers to the film's sensitivity to light or the film speed. Higher ISO ratings are more sensitive to light, so you can use them in dim conditions.

FILTERS: these are usually made of lightweight plastic or resin, sometimes glass. When placed over the camera lens, they alter the color of a scene or create special effects such as soft focus and multiple images. You can even use a strip of black stocking over the camera to make a soft-focus filter, but if you are using a pure color filter it must also cover the camera's light-

metering sensor so the loss of light is accounted for. Do not be tempted to use graduated filters as these will cause overexposure.

FOCAL LENGTH: this is the measurement which refers to the length of your camera's built-in lens. It refers to the distance between the front of the lens to the film plane inside the camera, measured in millimeters. If your camera has a fixed focal length, it will probably be a short focal length between 28mm and 35mm. If your camera incorporates a zoom, it could range from a short focal length such as 38mm right up to 70mm or even 140mm at its longest extension.

FOCUS LOCK: similar to a camera's exposure lock, this feature is controlled by half depressing the camera's shutter button. It is very useful for off-centered subjects, as most autofocus sensors work by latching onto the central section of the image. Point the camera at the subject, gently press the shutter button half way (without taking the picture) then turn to reframe the shot so the subject lies off-center as planned.

GRAININESS: faster films (ISO 400–1600) give more grainy-looking results than slow ones, because the light-sensitive particles suspended in the film's emulsion cluster together into clumps when struck by light, an effect which is less obvious with slow ISO speed films as the particles are smaller. Graininess is often seen as a nuisance, although it can be exploited to creative ends.

INFINITY MODE: this feature allows you to keep a scene sharp from front to back, gaining maximum depth of field. It is ideal for landscape scenes taken with a tripod.

ISO: this stands for 'International Standards Organization' – the authority that calibrates film speeds to ensure they are the same all over the world so that results can be predicted.

MACRO MODE: many compacts are designed with a built-in macro facility. This allows you to get closer than normal to small subjects such as flowers and babies to better fill the image frame.

MINIMUM FOCUS: every camera's lens has a minimum focusing distance. This means if you get too close to your subject it will not record sharply. The average minimum focusing distance for compact lenses is 20 inches from the subject.

PARALLAX ERROR: this refers to the problem of accidentally cutting off the top section of the subject, such as the top petals of a flower or the top of somebody's head. It happens when you get too close to a subject – the viewing lens shows a slightly higher vantage point compared to the view recorded by the taking lens.

RED-EYE REDUCTION: red-eye occurs when flash strikes the blood vessels at the back of the retina. Many cameras offer a pre-flash facility or bright light to encourage a portrait subject's pupils to contract before the main flash fires to make the exposure.

REMOTE CONTROL UNIT: a handset which transmits an infrared pulse to the camera from a distance to trigger the shutter remotely. This accessory is particularly useful for photographs of timid wildlife and for self-portraits and family groups.

SELF-TIMER: this is a built-in delay feature (usually two to ten seconds) which enables the photographer to take self-portraits and family groups including himself. Also useful for general tripod-mounted photography where pressing the shutter release button might risk camera shake.

SHUTTER SPEED: to make any photograph, the camera has an internal shutter mechanism which opens to allow light to reach the film. The speed with which it opens and closes dictates the length of the exposure, which is usually measured in fractions of a second.

SINGLE-USE COMPACTS: there are many designs available – with and without flash, waterproof, panoramic and even those offering a 3D picture. All you have to do is use up the film and send the whole camera in for processing.

TELEPHOTO: this is the longest end of a compact camera's zoom range, and focal lengths of 70mm, 85mm and 105mm are typical. Use the telephoto end of your zoom to enlarge a subject in frame, throw the background out of focus beyond depth of field, and to better isolate a portrait subject from her surroundings.

TRIPOD: this is the photographer's three-legged friend. Using a tripod holds the camera steady to prevent camera shake.

TUNGSTEN-BALANCED: this refers to the special films which are designed for use when shooting interior pictures lit with domestic tungsten light bulbs. With normal daylight-balanced films the tungsten light records everything in an orange color cast. Tungsten-balanced films help you gain more natural-looking results.

WIDE ANGLE: this refers to the short focal length offered by most fixed lens compact cameras. It is also the correct term for the shortest end of a zoom compact's lens range, and focal lengths of 28mm, 35mm and 40mm are typical. Use the widest end of your zoom to capture the beauty of a panoramic vista, to keep a tall building within the image frame if you cannot stand back, and to maximize depth of field to keep fore- and background sharp.

ZOOM BURST: this is the technique where the zoom lens is moved during an exposure for special tunnel-like effects.

Index

PICTURE ACKNOWLEDGEMENTS

Front and back cover All pictures from Zefa Pictures;
Mike Brown 73 bottom;
Duke of Edinburgh's Award Office 73 top right;
Sally and Richard Greenhill 6 center, 13 top, 18 top, 24 top, 27 top, 28 top, 64 top, 66 top, 71 center, 76 center, 77 top, 77 bottom, 78 bottom, 79 top, 79 bottom /Richard Greenhill 59 center;
Sean Hargrave 7 top left;
Robert Harding Picture Library 4/5 center, 14 top left, 21 bottom, 32 top, 38 top, 42 bottom, 67 bottom ,71 bottom /Andrew Mills 54 top right /Adam Woolfitt 1 center;
Roger Howard 48 bottom , 56 bottom, 69 center;
Robin Nicholls 74 top center, 74 top right, 75 top left;
Chris Rout 25 top, 43 bottom, 47 top, 50 top, 51 top left, 51 top right, 68 top, 72 top;
Tony Stone Images 7 center, 70 top /Dennis O'Clair 3 center /Lori Adamski Peek 2 bottom right, 20/21 top, 82 top /John Beatty 56 center, 58 center /Dugald Bremner 29 center /Peter Correz 3 bottom right, 88 center /Andy Cox 12 center /Joe Cornish 39 bottom, 87 bottom /Nicholas DeVore 17 center /Dale Durfee 22 bottom /John Garrett 60 center /Peter Gittoes 54 top left /Jon Gray 57 center /Mark Junak 84 center /Nicole Katano 15 top /Julie Marcotte 35 bottom /David Madison 74 /75 center /John Moss 63 top /Andy Sacks 34 bottom, 61 center, 62 top /David Sutherland 55 top left, 55 top right /Arthur Tilley 44 bottom /Jean-Marc Truchet 42 top;
Zefa Pictures 3 top right, 7 bottom, 8 top, 9 top, 10 bottom, 11 top, 13 center, 14 bottom, 14 top right, 16 center, 19 bottom, 20 top left, 22 top, 23 top, 23 bottom, 26 center, 30 top, 31 center, 33 bottom, 36 center, 37 top, 37 bottom, 40 center, 41 top, 45 bottom, 46 top, 48 top, 49 bottom, 52 center, 53 bottom left, 53 bottom right, 55 bottom, 59 top, 65 top, 65 center, 80/81 bottom , 81 top, 83 center, 83 top, 85 top, 86 center, 87 top, 89 top, 90 top, 91 top, 91 bottom.